CHARLES WHITE

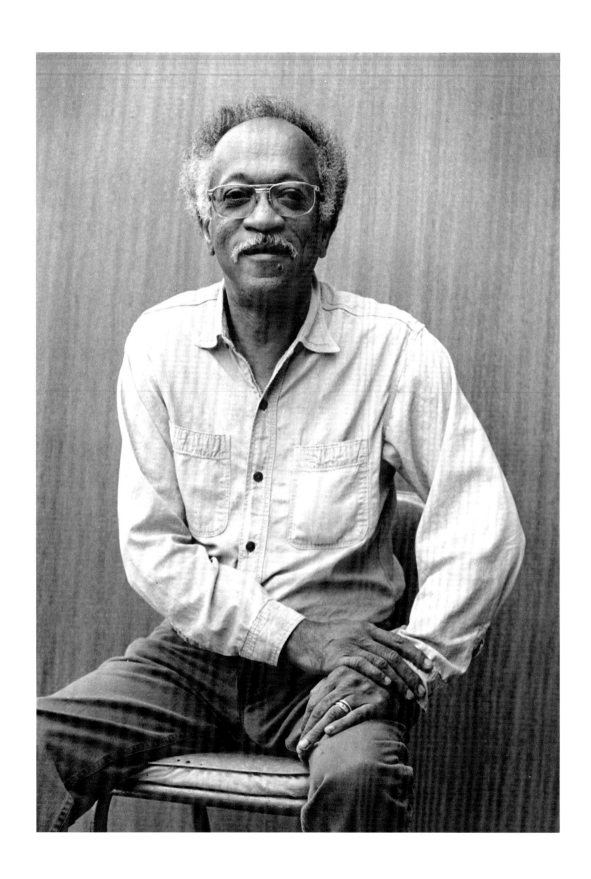

CHARLES WHITE

BLACK POPE

ESTHER ADLER

THE MUSEUM OF MODERN ART
NEW YORK

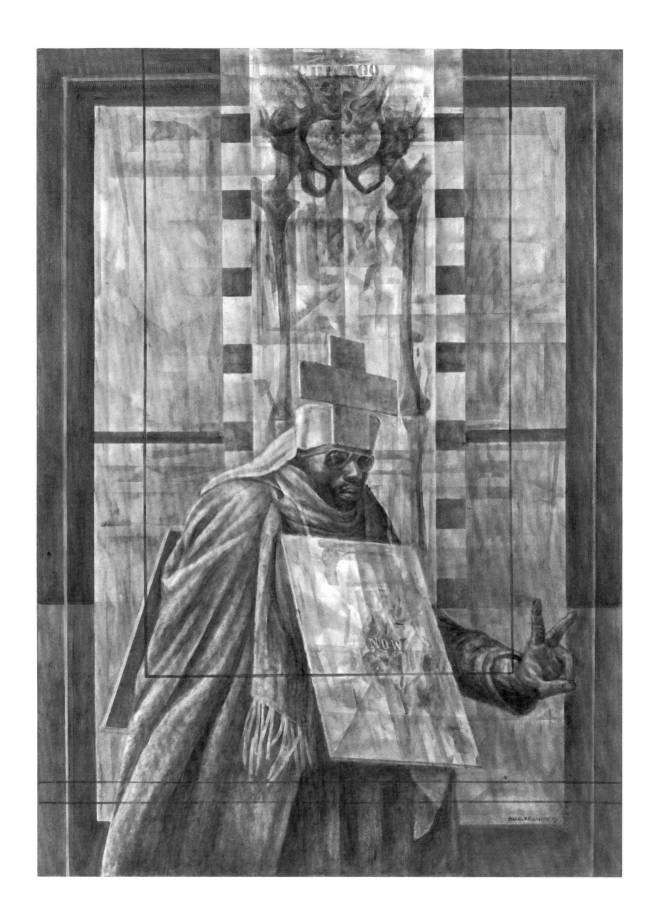

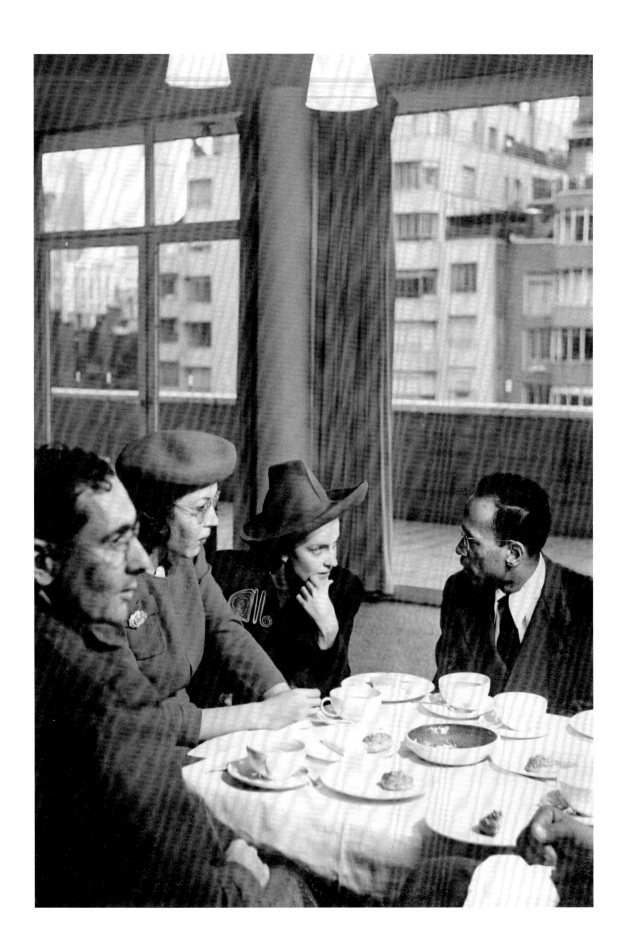

No work by Charles White better represents the richness and complexity of his practice than *Black Pope (Sandwich Board Man)*. The figure at the drawing's center, the broken field that surrounds him, and the work's multivalent symbols demand and reward the close looking exemplified by this book. Esther Adler, Associate Curator in the Museum's Department of Drawings and Prints, working with a number of her colleagues here and with others outside the Museum who knew the artist personally, both locates the unique power of this drawing and sets it in the context of White's life and career. One of her collaborators, for example, was Assistant Paper Conservator Laura Neufeld, whose technical examinations of the drawing give us a new understanding of White's methods and of the ways in which they supported his aesthetic goals. Another was the painter Kerry James Marshall, a former student of White's, who gave Adler further insight into the artist's practices and to whom we owe the discovery of the photographic source for *Black Pope*. . . . Although focused on a single drawing, this book aims to expand the way we see and understand all of White's work, adding much-needed contemporary consideration to the literature.

The Museum acquired *Black Pope* . . . in 2013. While this major late work was not White's first to enter the collection—we acquired six lithographs in 1970, followed by the etching *Missouri C* in 1976—it was the first drawing. We owe a significant debt of gratitude to the supporters of the Museum who helped us to acquire *Black Pope* . . . : Richard S. Zeisler (through Bequest and Exchange), The Friends of Education of The Museum of Modern Art, The Committee on Drawings, Dian Woodner, and Agnes Gund. No less critical to this book's success is the family of Charles White, particularly his son, C. Ian White, both for the support they provided during the book's preparation and ultimately for entrusting us with the drawing. It is my great regret that I cannot host Charles White for tea at the Museum, as my predecessor Alfred H. Barr, Jr., did in 1943, but to present our commitment to continuing scholarship on his work remains an enormous pleasure.

Glenn D. Lowry
Director, The Museum of Modern Art

Left to right: Alfred H. Barr, Jr., Elizabeth Catlett, Dorothy Miller, and Charles White at The Museum of Modern Art, New York, on the occasion of the exhibition *Young Negro Art*, 1943

ESTHER ADLER

CHARLES WHITE
BLACK POPE

In October of 1943, the artist Charles White had tea in the penthouse of The Museum of Modern Art. He was there to celebrate the opening of *Young Negro Art*, an exhibition of works by students at the Hampton Institute, a Virginia school founded expressly for African and Native Americans. But White was not a student at Hampton; a graduate of the School of the Art Institute of Chicago, this twenty-five-year-old had already gained national recognition. A photograph of him at MoMA on this occasion speaks to his status (p. 6): White and his wife at the time, the artist Elizabeth Catlett, sit with the Museum's founding director, Alfred H. Barr, Jr., and White himself is deep in conversation with Dorothy Miller, an associate curator at the Museum whom he had met a few years earlier. In fact their rapport is the most striking element of the photograph.

Thirty-five years later, in an interview published in 1978, just a year before his death, White asserted the guiding principle that had informed him from the beginning. The statement demonstrates the sense of purpose that might have caught Miller's attention decades earlier:

An artist must bear a special responsibility. He must be accountable for the content of his work. And that work should reflect a deep, abiding concern for humanity. He has that responsibility whether he wants it or not because he's dealing with ideas. And ideas are power. They must be used one way or the other.[1]

White's sense of mission, and his ability to translate that mission into images, were key to establishing his reputation and led to the respect and admiration in which he was held by peers and general audiences alike. Over the course of his life, from 1918 to his premature death in 1979, he lived in major cities across the United States, on the East Coast, the West Coast, and in the heart of the country, and he became a crucial figure in creative communities in all of them. Born in Chicago, he began his career there, revealing his sense of social responsibility from his earliest mature work onward and purposefully inserting black men and women, both historical and contemporary, into the American art of his time. In the 1940s and early '50s he lived mainly in New York, in an art world focused on Abstract Expressionism, but his dedication to the human figure continued, as did his commitment to a realistic visual style that assured maximum accessibility for broad audiences.

During White's final decades—in Los Angeles, where he moved in 1956—he was one of the few black artists to have gallery representation in the city, and this professional success, as well as his increasingly complex work, made him a beacon for both younger artists and peers. One former student of his, for example, is the artist David Hammons, who sought him out in 1968 at Otis Art Institute, where the older artist was then a teacher of drawing. White's influence extended not only to Hammons's work but to his understanding of the role of the black artist: "He's the only artist that I really related to," Hammons said in 1971, "because he is black and I am black, plus physically seeing him and knowing him. . . . he's the first and only artist that I've ever really met who had any real stature. And just being in the same room with someone like that you'd have to be directly influenced."[2] Hammons also picked up on the content of White's images: "In most of Charles White's art there aren't too many people smiling, and I like that in his things. There's always an agonized kind of look, I think, because there aren't many pleasant things in his past. He's gone through a lot of Hell. I know he has."[3] The painter Kerry James Marshall, another former student of White's, has remarked in a similar vein, "Under Charles White's influence, I always knew that I wanted to make work that was about *something*: history, culture, politics, social issues. . . . It was just a matter of mastering the skills to actually do it."[4]

What, then, are we to make of White's monumental 1973 drawing *Black Pope (Sandwich Board Man)* (p. 5)? A signature example of the oil-wash technique that White was known for by this point in his career, it shows the "black pope" of its title as a man wearing a heavy coat and scarf, a sandwich board, and a hat bearing a cross. The depiction is relatively readable, but who is this man? What is his message

and why is White bringing him to our attention? Where is he what is his context—
and what are we to make of the visual elements around him, including the lower half
of a human skeleton? If for White the artist by definition had to deal with ideas, what
are the ideas here?

Where White had formerly been committed to creating images with clear mes-
sages, *Black Pope* . . . and its complex figure and space reveal a new way of addressing
the social and the political, one in dialogue with the art of the 1970s and, for that matter,
of today. White's refusal of immediate answers in the drawing reflects a reimagining of
what he considered the artist's "special responsibility." *Black Pope* . . . at once extends
his lifelong commitment to addressing the social and political struggles of African
Americans, often by applying religious symbolism to images of social injustice and pro-
test, and reinvents his methods and strategies in the service of long-held ideals.

"IMAGES OF DIGNITY"

With the title of his book *Images of Dignity: The Drawings of Charles White* (1967),
Benjamin Horowitz, the owner of Los Angeles's Heritage Gallery and White's dealer
beginning in 1964, coined a phrase that has been applied to the artist's work ever
since. Horowitz wrote,

*In an era when the artist is expressing his detachment from the human condition by
a "cool" and geometric style, Charles White's superb drawings challenge this lack of
faith and self-involvement. Their epic quality affirms his deep concern for humanity,
his love of man and life, and his belief that brotherhood is not just a catchword. . . .
A warm understanding of the meaning of existence, man's aspirations and sorrows,
his inner spirit, but above all his dignity, form the central core of Charles White's love
affair with life.*[5]

The qualities that Horowitz championed were present even in White's ear-
liest works. As the artist was growing up in Chicago, the Great Migration of black
Americans, from the rural Southern states to the urban North, was transforming the
city.[6] His mother, Ethelene, had come there from Mississippi in 1914, four years
before he was born, and his extended family in the South would be a touchstone for
him throughout his life.[7] Drawn to art from a young age, White began taking classes
at The Art Institute of Chicago when he was in the seventh grade. Having received a

scholarship to continue his studies there after high school, he completed them in 1938, finishing two years of course work in just a year. As early as 1932, as a fourteen-year-old, he also joined the Art Crafts Guild, a group of black artists who organized to help disseminate formal art instruction, which few of them could afford, and to exhibit their work.[8]

By 1939 White was working for the Federal Art Project, a division of the Works Progress Administration (WPA)—the U.S. government program that both supported visual artists by employing them during the Great Depression and placed commissioned works in public buildings throughout the country. Here White began to make the murals that remain some of his best-known works, including *Five Great American Negroes* (1939–40; pp. 12–13).[9] In both subject matter and execution, the painting exemplifies White's early practice while also reflecting the social and cultural goals he shared with the other artists of the Art Crafts Guild. The "great American negroes" it shows—Sojourner Truth, Booker T. Washington, Frederick Douglass, George Washington Carver, and Marian Anderson—had been "selected by school children and readers of the *Chicago Defender* as those who have contributed most to the progress of the Race."[10] The mural itself speaks to White's desire to demonstrate on a grand scale the contributions of African Americans to their country's story, as well as to combat their absence from the mainstream historical narratives of his time.[11]

It was White's involvement with the WPA and with a project the agency supported, Chicago's South Side Community Art Center—cofounded by White and others in the Art Crafts Guild—that brought him to the attention of Dorothy Miller, then associate curator of Painting and Sculpture at The Museum of Modern Art.[12] Through her husband, Holger Cahill, the director of the Federal Art Project, Miller had a personal connection to the WPA and an interest in the artists working for it. In a letter of November 1941 to Fred Biesel, director of the Illinois chapter of the Federal Art Project, she wrote, "I am very eager to consider the possibility of exhibiting Charles White's big mural which I saw uncompleted at the Project last summer. . . . I would also want to include some of those big, handsome drawings of his—studies for his murals, and the studies for his other mural which I saw exhibited at the South Side Art Center, and possibly a few easel pictures."[13] The "other mural" that Miller saw studies for was likely *Five Great American Negroes*, completed in 1940; the "big mural" was certainly *Chaotic Stage of the Negro, Past and Present* (c. 1940–41; pp. 14–15, 16), a nine-by-twenty-one-foot two-panel work on canvas, intended for the George Cleveland Hall Branch of the Chicago Public Library, that would have been in process when Miller visited the

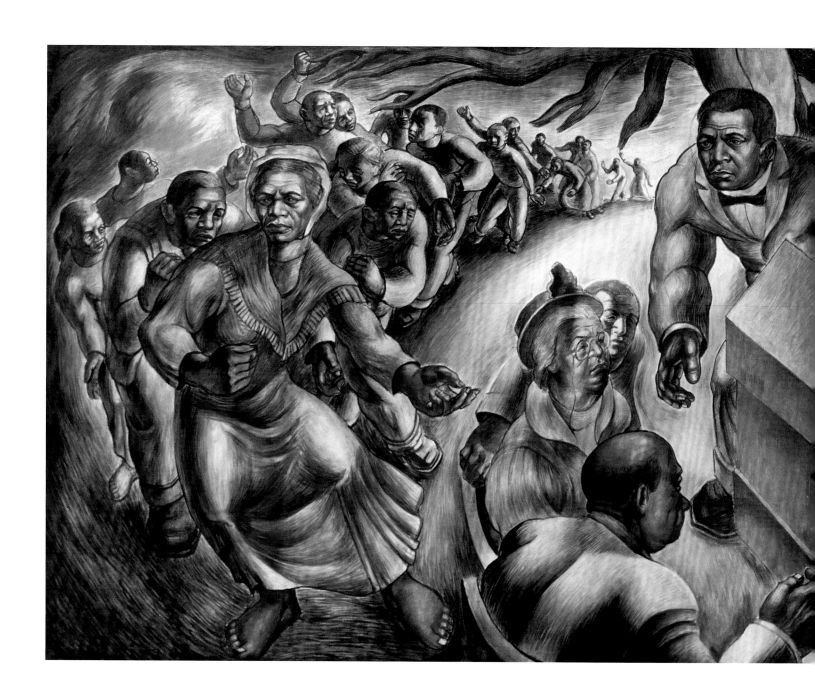

Charles White. *Five Great American Negroes*. 1939–40.
Oil on canvas, 60 in. x 12 ft. 11 in. (152.4 x 393.7 cm).
Howard University Gallery of Art, Washington, D.C.

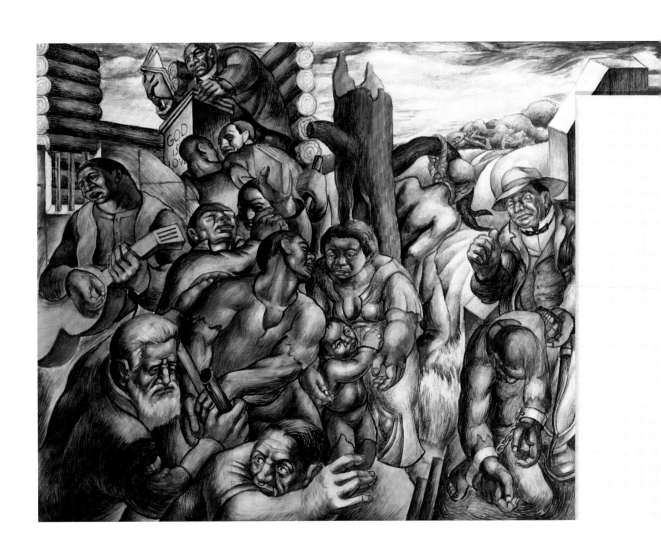

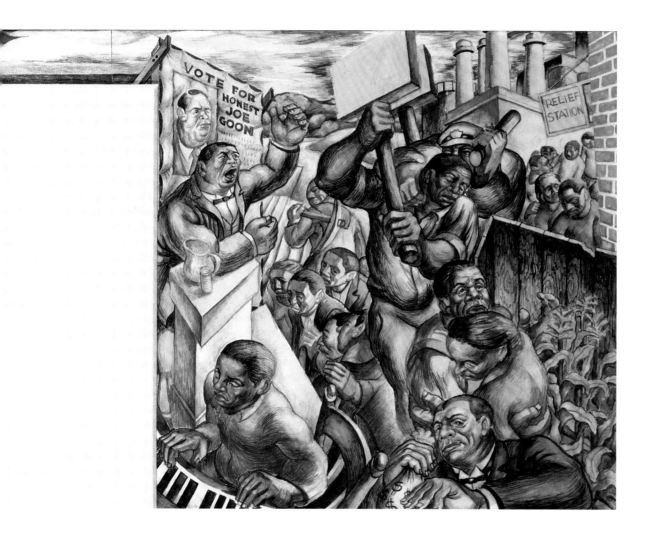

Charles White. Study for *Chaotic Stage of the Negro, Past and Present*. 1940.
Tempera on illustration board, 16 ¼ x 38 ⅝ in. (41.2 x 98.1 cm).
Courtesy Michael Rosenfeld Gallery LLC, New York, NY

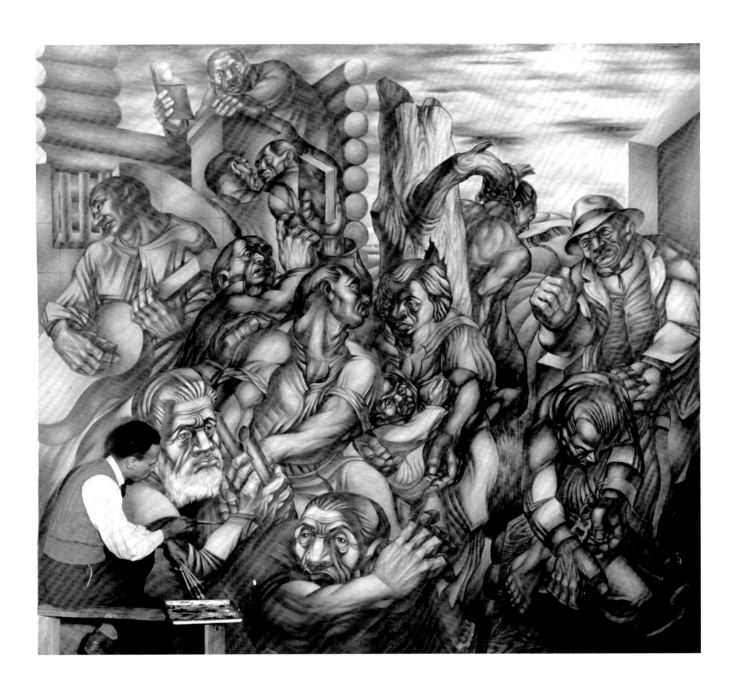

White working on *Chaotic Stage of the Negro, Past and Present.*
Chicago Public Library, Special Collections and Preservation Division, WPA 132

city but was never completed and is now lost.[14] The exhibition in which Miller hoped to include this painting was *Americans 1942: 18 Artists From 9 States*, the first in a now legendary series of six shows, collectively known as the *Americans* exhibitions, that she organized between 1942 and 1963. She left the work out in the end,[15] but her enthusiasm for it reflects both its strength and the broader response to White's art at the time: his drawing *There Were No Crops This Year* (1940) won first prize at the *Exhibition of the Art of the American Negro (1851 to 1940)*, organized by the distinguished curators and scholars Alonzo Aden and Alain Locke and on view in Chicago in 1940, and works of his were also exhibited at the Library of Congress that year.[16]

White left Chicago in 1941 to join his new wife, the artist Elizabeth Catlett, at Dillard University in New Orleans. Over the next few years the couple lived in New York, traveled in the South, and worked at the historically black Hampton Institute (now Hampton University) in Virginia. There White painted another major work, *The Contribution of the Negro to Democracy in America* (1943), his only mural made directly on the wall of a building.[17] With its dense composition of figures surrounding an axis of factory machinery, the work testifies to the influence on White of the Mexican muralists José Clemente Orozco, Diego Rivera, and David Alfaro Siqueiros.[18] In fact White had planned to use funding received through a Julius Rosenwald Fellowship to visit Mexico to study with these artists, but when the military draft board denied his request to leave the country, he ended up attending the Art Students League in New York, then going to Hampton, where he executed the mural.[19] White was drafted into the army in 1944; there he contracted tuberculosis, from which his recovery was long and slow. In 1946, however, he and Catlett were finally able to go to Mexico, where he met Orozco, Rivera, and Siqueiros, as well as the printmakers of the progressive workshop Taller de Gráfica Popular.[20] His Mexican experience affected him profoundly: "Mexico was a milestone. I saw artists working to create an art about and for the people. This had the strongest influence on my whole approach. It clarified the direction in which I wanted to move."[21]

White's time in Mexico was also one of personal change: his marriage ended there (he and Catlett would divorce officially in the United States in 1947). Returning to New York, in 1950 he married Frances Barrett, a social worker he had met years earlier. Both were members of the Committee for the Negro in the Arts, an organization that included such prominent figures as the singers Paul Robeson and Harry Belafonte, the actors Ruby Dee and Ossie Davis, and the poet Langston Hughes, and that aimed both to fight racial stereotypes in the popular media and to promote

African Americans' contributions to American culture. White exhibited regularly, with the ACA Gallery, and in 1951 he traveled in Europe, including visits to East Berlin and Moscow.[22] In 1956, the couple moved to Los Angeles, mainly to ease White's struggle with the aftereffects of tuberculosis. He would live in the Los Angeles area for the rest of his life.

It was during this chapter of White's career that Horowitz published his 1967 monograph, described by the artist as "the first book printed on a living black artist in U.S. history."[23] The book included a foreword by Belafonte, an introduction by the art historian James Porter, and an essay by the dealer himself. Most important, it included almost ninety pages of black and white illustrations of White's work, from childhood drawings and the Chicago murals, through paintings and drawings made in New York, to work completed in Los Angeles just the year before. This pictorial history clarified the qualities that Horowitz so admired: White's consistent focus on the monumental African-American figure, and the empathy reflected in his extremely carefully drawn images. His admiration for the people he depicted, whether they were historical figures or anonymous or imagined subjects, is clear, his respect for them as human beings obvious. But the overarching categorization of these works as "images of dignity," now widely accepted, has resulted in a narrow consideration of White's work, one that falls short of acknowledging its full complexity.

PREACHERS

Black Pope . . . can be situated in a lineage of representations of men engaged in religious practice that runs through most of the artist's career, and the differences in these images over time speak to both the development and the consistency of his art. White's 1940 work *The Preacher* (opposite) is one of the more modestly sized paintings he produced at the height of his mural phase. A lone man stands before us, the tatters in the right-hand sleeve of his shirt suggesting a life hard lived. In his powerful, oversized hands he holds a small book, which he presents to us with striking tenderness. This preacher emerges from an undefined space that is alive with color and movement, intimating the emotional and spiritual activity that informs what is essentially a still moment of interaction: the subject is a man awaiting our response.

The work's title suggests that what the man is offering is religion and that his book is the Bible, but the book's cover bears no text and nothing about the man's clothing or surroundings suggests an affiliation with a church.[24] Perhaps he is preaching salvation through education, like the figure at the far right of *Five Great American Negroes* who offers a gesture of openness and possibility to a man holding a book.[25] White himself said he had been "saved" by time spent in public libraries as a child, with the books he read there forming the foundation of his education.[26] The absence of a detail that would define the message of the preacher of 1940 links this work with

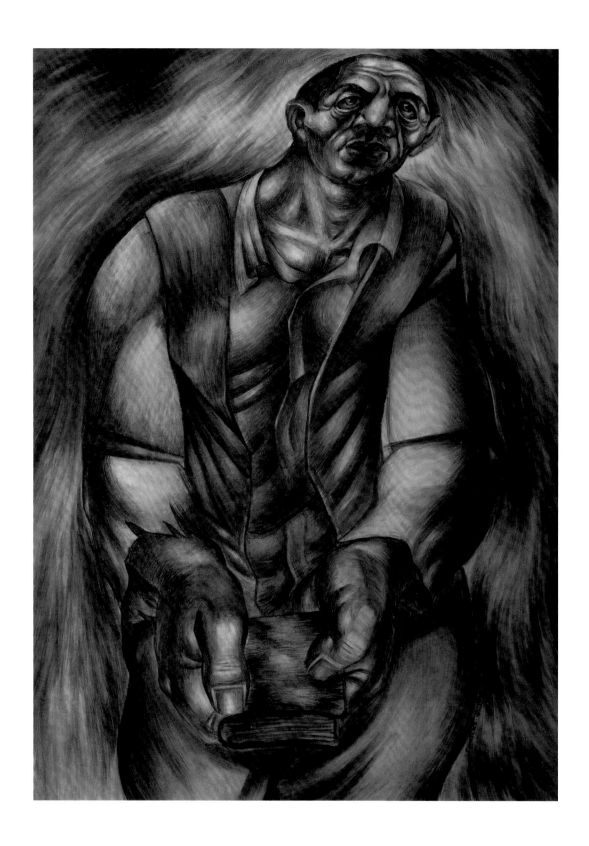

Charles White. *The Preacher*. 1940.
Tempera on board, 30 x 21½ in. (76.2 x 54.6 cm).
Collection the Davidsons, Los Angeles, California

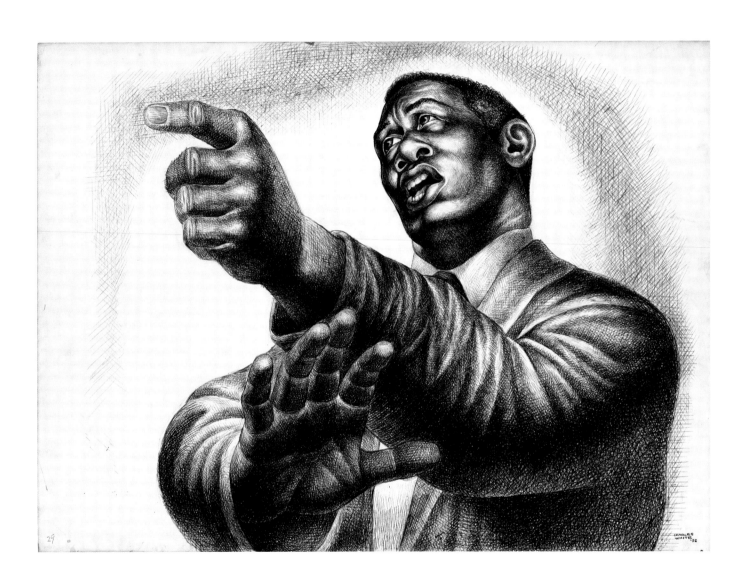

Charles White. *Preacher*. 1952.
Pen and ink and graphite pencil on board,
22¹³⁄₁₆ x 29¹⁵⁄₁₆ x ³⁄₁₆ in. (57.9 x 74.6 x 0.5 cm).
Whitney Museum of American Art, New York. Purchase

Black Pope . . . , made over thirty years later, even as both works also reflect the significance of preaching in African-American religious practice.[27]

In 1952, White made another work titled *Preacher* (opposite), a drawing quickly acquired by New York's Whitney Museum of American Art. Like the earlier painting, it depicts a single male figure, his body cropped below the chest, a halo of cross-hatching minimally suggesting the surrounding space. White described the drawing in a questionnaire he completed for the Whitney:

The subject of this work is a Negro Minister. Contrary to popular portrayals, Negro ministers for the most part represent and reflect the aspirations of and struggles of the Negro community for full and equal participation in our society. Too often the Negro minister has been portrayed as a buffoon and not reflecting the dignity, strength, and concern for the basic problems of living that face his congregation. So I have chosen to attempt to bring out the militant qualities rather than the ones of humility. Many years of my youth was [sic] spent in church activities, and my grandfather was a country minister. I was perhaps thinking mostly of him and the work that many like him are doing in the South today.[28]

White's statement clarifies the identity of this preacher, but once again the image itself makes no overt reference to religious practice. This is surely because, although White did not say so in his Whitney questionnaire, the drawing is a portrait of Robeson, a founder of the Committee for the Negro in the Arts and a personal friend of White's. Indeed Robeson himself captioned the work "Drawing of Paul Robeson by the distinguished artist Charles White" when he reproduced it on the front page of his newspaper *Freedom* in 1952, accompanying an article on his presentation of a petition to the United Nations accusing the U.S. government of genocide against black Americans.[29] White had already depicted Robeson in his Hampton Institute mural *The Contribution of the Negro to Democracy in America*, showing him with arm outstretched in a similar gesture.[30]

A beloved figure in the United States and abroad, Robeson used his celebrity to fight for social justice. This and his links with the Communist Party, however, including repeated visits to the Soviet Union, made him the target of conservative political forces and the victim of persecution in his own country. In 1950 his passport was revoked and he was banned from American television, two of many attempts to discredit and diminish him.[31] White's image amplifies Robeson's message and voice.

Preacher celebrates both a radical figure of the African-American left, for those who recognize him, and a powerful but anonymous preacher, for those who do not. This allows the drawing to appeal to a wide range of audiences, including politically adverse ones.[32]

As different as the black pope of 1973 is from White's preachers of 1940 and 1952, the three works stand in dialogue with each other and have related qualities of urgency and emotion. Their differences in tone, style, and, most tellingly, the way their figures draw in or push back the viewer reflect the changes in White's circumstances and environment in the periods when they were made. When he painted his 1940 *The Preacher*, he was twenty-two years old and embedded in a cultural community in Chicago whose activism had achieved recognition and opportunities for black artists. Meanwhile the U.S. government, through the WPA, was actively supporting the arts in a previously unparalleled way. White's faith in the ability of art to communicate with an audience and effect change is apparent in *The Preacher*, whose figure, frontally positioned with eyes focused on some broader scene beyond the frame, demands our attention and response. If he himself does not look entirely optimistic, the artist's presentation of him, open and vulnerable, suggests a confidence that the viewer will engage with him.

Twelve years later an older White, physically scarred by tuberculosis but happily remarried, exhibiting regularly, and once again part of an artistically and politically active community, this time in New York, created a very different image. This preacher, however, still signaled the artist's belief in the power of his imagery: the 1952 drawing not only channels Robeson's magnetism but asserts White's sense of his own abilities as both draftsman and communicator. In the Cold War America of the 1950s, White was no longer the beneficiary of the government's support but the subject of its suspicion. (In 1951 he had been called to appear before the House Un-American Activities Committee, although the request was ultimately dropped.)[33] In this adverse context, his decision to draw Robeson at all, much less as a powerful preacher, speaks to both men's shared commitment to social justice, for African Americans and all oppressed peoples, and to White's refusal to bow to political pressures to distance himself from his community.

Black Pope . . . , created two decades later, reflects another shift in White's practice. It cites religion more explicitly than either of the two earlier *Preacher* images, but suggests a more complicated position on Christianity and its ability to effect social change. White said in the 1978 interview,

In all the years that Christianity has been around, I don't think it has changed mankind one iota, not as it relates to man's attitude towards his fellow man. In the end, religion boils down to an attitude. And as an attitude, it hasn't done one thing to bring about better relations among men. Although billions of people have been converted to Christianity down through the years, what has come from their conversion in terms of fashioning a lasting system of brotherhood? Absolutely nothing![34]

The frustration here, the sense that Christianity's social promises have gone unfulfilled, can also be felt in *Black Pope (Sandwich Board Man)*, which reflects an acknowledgment of humanity's failure to reach the ideals that White had been fighting for his entire life. And, like the *Preacher* images of 1940 and 1952, the 1973 *Black Pope* . . . reflects the circumstances of White's life. Created by a recognized fifty-five-year-old professional with both gallery representation and a full-time teaching position, as well as two young children, it reflects only qualified expectations about the pace and possibility of social change. The White of the 1970s was certainly no less committed to African Americans' fight for equality, and no less convinced of the critical role of art and artists in that fight. But from his position as an elder statesman, a role model for the younger artists, students, and citizens around him, his way of addressing the problems of racism was less insistent on a single approach or solution. The figure of the black pope embodies this change: where the earlier preachers are clearly defined and face or reach out to the viewer, he is in some way inaccessible. Body shrouded in drapery, eyes covered, he appears sealed in his own space, barely engaged with what lies beyond it. If he addresses the viewer at all—and a sandwich board implies public address—it is in a less declarative, more brooding kind of voice.

But if *Black Pope* . . . , in its enigmatic complexity, does not immediately look like an "image of dignity," that may say more about the limitations of Horowitz's signature phrase than about the work itself. Ultimately the connections among these pictures—three images of black men made at three very different historical moments—highlight both the consistency of White's goals and the evolving and responsive nature of his practice in both message and style. Created in a post-civil-rights-era America, after the widespread political and social upheavals of the 1960s and at the end of the Vietnam War, the black pope is a preacher for his time.

THE BLACK POPE IN 1973

The consistency of White's views on the social role of art is apparent in statements made throughout his life. He reiterated in 1978 that

art must be an integral part of the struggle. It can't simply mirror what's taking place. It must adapt itself to human needs. It must ally itself with the forces of liberation. The fact is, artists have always been propagandists. I have no use for artists who try to divorce themselves from the struggle.[35]

As the social realities of African Americans changed over time, White's work did as well, and he pursued new ways of supporting "the struggle." Yet while *Black Pope . . .* continues to manifest his lifelong dedication to fighting racist injustice, it also retreats from the direct polemic of, for example, his celebratory portrait of Robeson.

The mysterious pope at the center of the work is based on a photograph in Leonard Freed's book *Black in White America*, published in the late 1960s.[36] Kerry James Marshall discovered this link through his own habit of collecting images of the black figure, and the source was later confirmed by White's son, C. Ian White, who located the artist's own copy of the book.[37] A photojournalist known for documenting violence and injustice, Freed "was struck afresh by the problem of Negroes in American life," according to the book's publisher, when he returned to the United States after a period of travel abroad. He took the photographs eventually published in *Black in White America* during a six-month tour of the country in 1963.[38]

Freed juxtaposes his photo of a street preacher, whom he probably saw in Raleigh, North Carolina, with other images of religious activities.[39] In White's personal copy, the spread is marked by a folded corner and is heavily stained with brown fingerprints, probably from the artist's oil-wash medium (opposite). White does not reproduce Freed's photograph exactly, repeating only the man's basic figure, including his draped coat, with one arm tucked inside out; his scarf; and his unique hat. Gone are the preacher's Bible, his right hand clutching a handkerchief, and his despairing expression. Meanwhile there are also additions: the left hand with its peace sign, the aviator sunglasses masking the face, and the sandwich board bearing the word "NOW." On top of its imagery, *Black Pope . . .* includes a group of thin ruled lines: a vertical rectangle that extends from the top edge to just below the center of the sandwich board, and two horizontal lines that run completely across the picture just below the sign's bottom edge. In some of these details White may have been responding to

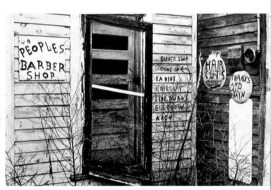

The town isn't big; one tidy business street and at the dirty end a small side street of dilapidated buildings for the colored. For the colored: colored bars, colored barber shops, colored eating places and a colored poolroom. Weekends the side street is packed and noisy while the money flows from the hands of poor farm laborers. Sitting in what he called his office, he said he wanted me to get it straight before I left town. 'What I need is a large hall for more tables. Without the extra tables I do little better than break even. Joke about poolrooms, but this is the only clean recreation the kids have in this town, and I keep it clean, no gambling. The trouble is, the kids come up here, see all tables occupied and go back downstairs to the bars, and wind up in jail.' Why didn't he get a larger place if he needed it, I asked. 'This is the only place they'll let me have,' he said. He tried often to move away from the bars onto neighboring streets, but the whites owned the land, and no amount of money was sufficient when a Negro wanted to establish himself in another part of town. The whites just laughed in his face when he approached them with his proposition.

'They would just laugh and laugh,' he said, 'just laugh.'

Leonard Freed (American, 1929–2006). *Black in White America*
(New York: Grossman Publishers, n.d. [late 1960s]).
Spreads, pp. 28–29 and 54–55, from White's personal copy of the book

other pictures in Freed's book: twenty-five pages after the primary image, for exam-
ple, is a spread, also marked in the artist's copy by a folded corner, that includes
a photograph of a blind figure wearing dark glasses and a small sandwich board.
Immediately across from this image is a photograph of a dilapidated barber shop
whose door and angled screen door may resonate with the framing structure sur-
rounding the black pope (p. 25). A later image includes a civil-rights protester wear-
ing a T-shirt demanding action "NOW!"[40] But *Black Pope* . . . does not simply rework
Freed's photographs; not only was White highly selective in his choices of details to
reproduce, but he added evocative symbols of his own.

Little of the black pope's body is visible to us; it is hidden under a mass of
clothing and signage, from which only his left hand emerges.[41] The figure's gesture,
the peace or victory sign (opposite)—one of the inventions that White added to
Freed's image—was common in the counterculture of the 1960s and early '70s, when
the Vietnam War was a divisive public issue in the United States.[42] Although the U.S.
government signed a peace treaty with North Vietnam in January of 1973, the same
year *Black Pope* . . . was completed, the social and cultural effects of the war were
ongoing and enormous.[43] As *New York Times* columnist James Reston wrote at the
time, "Few Americans challenge the proposition that for good or bad, something has
happened to American life—something not yet understood or agreed upon, some-
thing that is different, important and probably enduring."[44] Those effects crossed
racial boundaries but had particular resonance among African Americans, who, at the
height of the conflict, were participating in their highest proportion in an American
war to that date.[45] As a veteran, drafted but discharged after contracting tuberculosis,
White was acutely aware of the lot of the black soldier, and of the irony of being asked
to fight for freedom abroad while being denied equality in the United States.[46] The
black pope's ambiguous gesture—his hand held low, emerging from behind his sand-
wich board—signals a skepticism about the possibility of peace, whether in Southeast
Asia or in the turbulent America of the late 1960s and early '70s.

The height of U.S. involvement in the Vietnam War, roughly 1965–69, coin-
cided with the waning years of the civil rights movement, the assassination of Martin
Luther King, Jr., in 1968, and the rise of a more militant black-power movement. White
lived through all this, and through many personal experiences of racism and violence in
earlier decades.[47] The figure of the black pope, his expression hidden from the viewer,
in some way reflects America's failure to achieve peace on any front, domestic or inter-
national. Yet White's belief in humanity, together with his certainty that change would

be achieved in particular by the efforts of his own community, pervaded his work and life to the very end. Asked in the 1978 interview how he avoided the "cynicism and alienation" generated by a world of "misery and oppression," he replied,

I'm able to work because I don't find those negative elements in my people. The fact is, I'm nourished by my people. . . . White people are too lethargic to the existence of the problem. My God, my people have survived for three hundred years on the basis of our humor. We've used that humor to bring about constructive changes in society. We've always been in a constant process of growth. . . . We're indestructable![48]

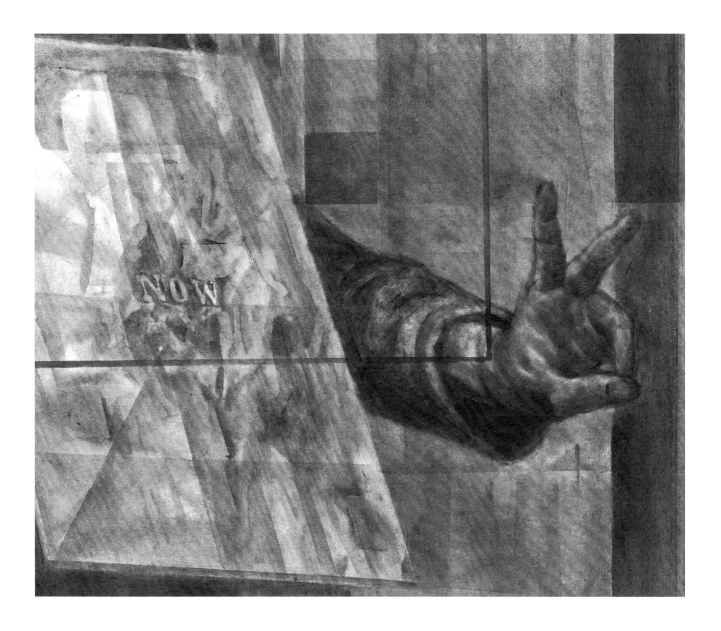

Charles White. *Black Pope (Sandwich Board Man)* (detail). 1973

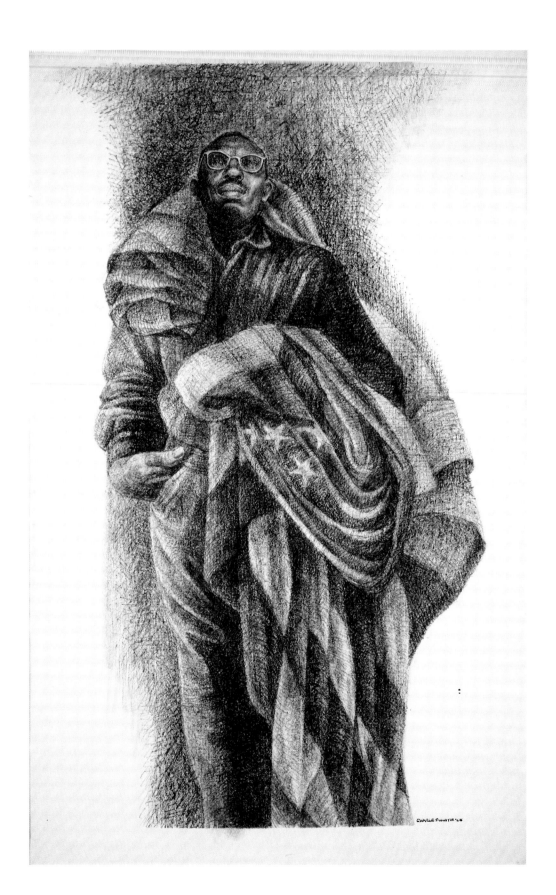

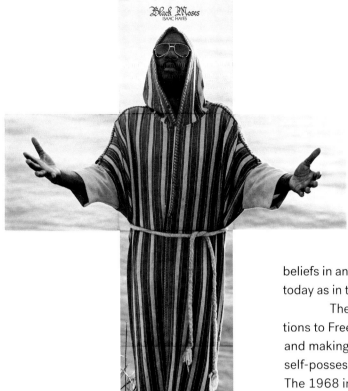

This faith in the ability of African Americans to generate change is White's most enduring theme, and *Black Pope* . . . remains connected to it. But the skepticism and doubt that are palpable in this image are partly responsible for its power and continuing relevance. That White was willing to make a work like this, seemingly at odds with his most deeply held beliefs, reflects a willingness to interrogate those beliefs in an ongoing search for the human and social resolutions that, today as in the 1970s, remain elusive.

The black pope's aviator sunglasses, another of White's additions to Freed's original image, both block access to him, hiding his eyes and making his expression unreadable, and provide an element of cool self-possession. White had drawn figures wearing sunglasses before. The 1968 ink drawing *The Brother* (opposite), for example, shows such a man, and one who, like the black pope, is so completely swathed in cloth that only his face and a single hand—his right hand, sticking nonchalantly out of his pants pocket—remain bare. This drawing, though, has a clarity in complete contrast to the later work.

The cloth that envelops the brother is an American flag; his sunglasses may hide his gaze, but his expression—head high, lips just slightly upturned—is confident and self-assured.

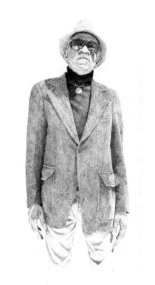

To the extent that the black pope recalls this figure, he also resonates with a wide range of imagery of black men in the popular culture of the 1960s and '70s. Take, for example, the photograph of Isaac Hayes on the cover of his 1971 LP *Black Moses* (above), showing the soul singer biblically garbed but wearing sunglasses. A 1977 drawing of White by one of his students, Kent Twitchell (right), suggests that the artist's own personal style during that decade extended to aviators. By giving the man in Freed's photograph this simple accessory,

Charles White. *The Brother*. 1968.
Ink on board, 60 x 38 in. (152.4 x 96.5 cm). Private collection, Los Angeles.
Courtesy Michael Rosenfeld Gallery LLC, New York

Foldout cover of Isaac Hayes's LP *Black Moses*, 1971,
designed by Larry Shaw. 48 x 36 in. (121.9 x 91.4 cm).
Courtesy Stax (Enterprise) Records/Concord Music Group Inc.

Kent Twitchell (American, born 1942). *Portrait of Charles White*. 1977.
Pencil on paper, 11 ft. x 48 in. (335.28 x 121.92 cm).
Los Angeles County Museum of Art. Gift of Benjamin Horowitz

White transformed him. While the image later in Freed's book, of a blind person begging for change, was evidently also in White's mind, the cool connotations of sunglasses seem to have the stronger resonance in *Black Pope . . .* , grounding the figure in the current moment.

Knowing White's history of political activism both in and outside his art, the sunglasses may further suggest a connection with a group that was prominent at the time: the Black Panthers. As historian Peniel E. Joseph writes, "The Black Panthers' iconography—which included black leather jackets, tilted berets, sunglasses, and guns—became an enduring symbol of the revolutionary posture that galvanized a generation of young Americans during the late 1960s."[49] That iconography was widespread: according to art historian Erika Doss, "Reporters and photographers from *Life* and *Time* to *Ebony* flocked to the Panthers, certainly led by the promise of a good story about American anarchy and racial conspiracy but perhaps more obviously attracted by the Panthers' own *visual* presence. With their black berets and leather jackets, their Afros, dark glasses, raised fists, and military drill formation, the Panthers made great visual copy."[50] The black pope's shapeless coat and oddly shaped hat differentiate him from those "fashion plates of black insurrection," in Henry Louis Gates's phrase, and his chosen weapons, a sandwich board and in particular a peace sign, differentiate him from their guns.[51] Yet in California in the early 1970s, his shades could still have been seen as an echo of and link to the Black Power movement.

For Emory Douglas, meanwhile—the Black Panthers' minister of culture, and the artist most responsible for the visual imagery that communicated the party's mission—White's "images of dignity" were complacent. He saw White as engaged in a different struggle from his own: "Reproaching the social realism of an earlier generation of black artists, [Douglas] remarked, 'Charles White used to draw various pictures dealing with the social injustices the people suffer but it was civil rights art.' White's 1950s images of 'mothers scrubbing the floors' were 'valid,' said Douglas, but they weren't geared toward raising revolutionary consciousness."[52] White, who objected to "the whole treatment of women in our society" and to "this ridiculous icon called 'macho-ness,'" might for his part have rejected the Panthers' hypermasculine image, but in many of their civic goals the movement's activists would likely have found him a supportive observer.[53] In 1971, in fact, after the scholar and activist Angela Davis was charged with kidnapping, murder, and conspiracy—charges widely thought to have been motivated by her political activities, which included involvement with the Black Panthers and the Communist Party—her supporters won White's

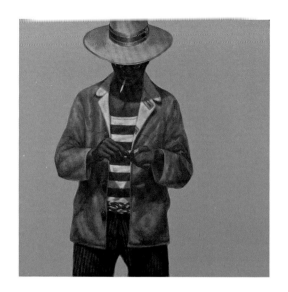

permission to use his lithograph *Love Letter #1* (p. 38) in a campaign to release her on bail.[54]

The aviator-clad black pope also recalls figures in the paintings of another African-American artist of the time, Barkley Hendricks (left). By 1973, the twenty-eight-year-old Hendricks had earned his MFA from Yale and was exhibiting portraits of his young black friends and family across the United States. Both he and White were included in the 1971 exhibition *Contemporary Black Artists in America*, at New York's Whitney Museum of American Art, their works reproduced just two pages apart in the catalogue.[55] Hendricks's art has sometimes been seen as antithetical to White's. For Richard J. Powell, Hendricks introduced

a narcissistic, sometimes wary demeanor to black portraiture. [White's] heroic black women and men, with their soulful faces and rugged hands, took amazing shape with White's pencil and ink cross-hatchings and, for most of the 1960s, embodied the dreams and ideals of the modern civil rights movement. In contrast, Hendricks's The Way You Look Tonight/ Diagonal Graciousness *luxuriates in a cynical individualism whose toothpick-chewing, bubblegum-blowing informality would have been blasphemous for Charles White. . . . That there was even space in black figuration to counter Charles White's corporeal loftiness and interject an enigmatic, post–civil rights era black individual was Hendricks's contribution to American art.*[56]

The unidealized, enigmatic specificity that Powell finds in Hendricks's figure, though, fits White's sandwich-board man just as well. *Black Pope* . . . suggests a new approach on White's part to addressing "post–civil rights era" audiences. If his earlier figures were too lofty, too removed, for viewers in 1973, the shades-wearing, V-sign-brandishing street preacher was better equipped to connect.

Barkley L. Hendricks (American, 1945–2017). *Down Home Taste*. 1971.
Oil and acrylic on linen canvas, 48 3/4 x 48 5/8 in. (123.8 x 123.5 cm).
Courtesy the Office of the Dean of Students, Cornell University.
Gift of Michael Straight to the Willard Straight Hall Art Collection

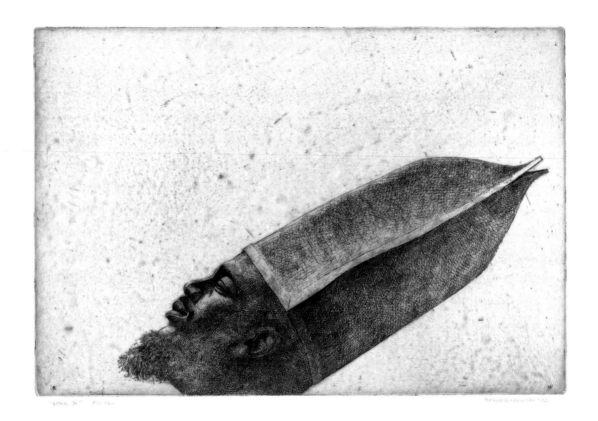

Charles White. *Pope X*. 1972.
Etching, 25⁵/₁₆ x 34¹/₁₆ in. (64.3 x 86.5 cm).
Publisher: unknown. Printer: Joseph and Hugo Mugnaini, Los Angeles.
Edition: 25. The Museum of Modern Art, New York. John B. Turner Fund, 2013

"AN AFRICAN POPE?"

White produced several images of popes in the 1970s. *Pope X* of 1972 (opposite) is a large-scale etching of the head of a man wearing a traditional papal miter. Video footage probably dating from later in the decade shows White drawing another such image: a large-scale, full-length figure in a miter that the artist described as inspired by clergymen he had encountered during his youth in Chicago.[57]

This focus on the papacy reflected a contemporary interest in the idea of a black pope. In 1972, Philip Alford Potter, a Methodist from the Caribbean island of Dominica, became general secretary of the World Council of Churches, and an article on him in *Time* magazine was titled "Black 'Pope.'"[58] In August 1973, *Encore* magazine ran an article titled "An African Pope?" (above), a copy of which remains among White's papers in the Archives of American Art.[59] The author, Sam Uba, was considering rumors that Pope Paul VI would retire and be replaced by a black cardinal, a possibility he found entirely plausible. Ultimately the prediction proved wishful thinking: Paul VI would remain pope until his death, in 1978, and has been followed in the office by four white men to date.

Organized religion, of course, has played a significant role in black life in the United States, and many African-American artists, including White, have depicted biblical figures as black (below).[60] White's c. 1949 linocut *Untitled (Bearded Man)*

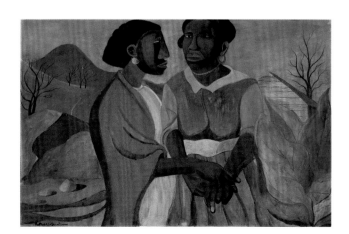

"An African Pope?" *Encore* magazine, August 1973

Romare Bearden (American, 1911–1988). *The Visitation*. 1941.
Gouache, ink, and pencil on brown paper, 30 ½ x 46 ½ in. (77.5 x 118.1 cm).
The Museum of Modern Art, New York. Gift of Abby Aldrich Rockefeller
(by exchange). Acquired with the cooperation of the Estate of Nanette Bearden
and the Romare Bearden Foundation whose mission is to preserve the legacy
of the artist, 2014

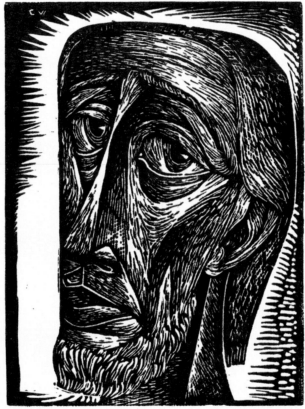

"Bearded Man" 17/18 CHARLES·WHITE

Charles White. *Untitled (Bearded Man)*. c. 1949.
Linoleum cut, 10½ x 8⁵⁄₁₆ in. (26.7 x 21.1 cm). Publisher and printer: the artist, New York.
Edition: 18. The Museum of Modern Art, New York. John B. Turner Fund, 2013

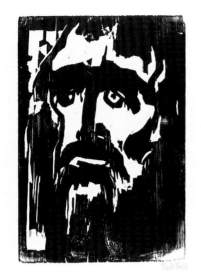

(opposite) makes no direct reference to a biblical character or story, but the man's sorrowful gaze, and the suggestion of a halo shape around his head, imply that he is a religious figure or even Christ himself. White's choice of the linocut medium also links his print with the German Expressionists' use of the related woodcut method for religious depictions (left).[61] The figure in the large linocut *Solid as a Rock (My God Is a Rock)* (1958; p. 36), while again not specifically biblical, wears a choir robe and is unmistakably a symbol of strength grounded in religion. She is anchored by her large bare feet, presumably resting on the foundation named in the popular hymn "I Got a Home in That Rock," White's inspiration for the work's title.[62] As that title suggests, the figure is unshakable; White's image celebrates the power and stability found through faith.

Another print infused with religious references is the 1945 lithograph *Hope for the Future* (p. 37). A seated woman looks warily ahead, her infant son held on her lap in her powerful, sheltering hands. The window behind them frames a landscape in which a noose dangles from a bare tree—an unmistakable reference to lynching. Showing a contemporary black mother anxiously contemplating her dangerous world, the work also echoes the iconography of the Madonna and Child.[63] By linking Mary and Christ with African Americans, White not only addresses issues of racial oppression but presents them in an instantly understandable way.[64]

Like *Black Pope . . .* , *Love Letter #1* of 1971 (p. 38) gives religious and political overtones to contemporary imagery. The strength of the figure here is communicated not through the solidity of her body—which is in fact hidden but for her head, neck, and shoulders in the work's upper quadrant—but through the directness of her gaze. If her full, naturally styled hair is seen as a halo, the image can be read as a religious icon, and the roses in its center as alluding to the traditional association of the Virgin Mary with that flower. In 1971, however, this halolike hairstyle—an Afro—had other implications: many observers would have seen this young black woman as politically active or even militant. One of the style's most famous wearers was in fact Angela Davis, who, more

Emil Nolde (German, 1867–1956). *Prophet*. 1912.
Woodcut, 19 11/16 x 14 3/8 in. (50 x 36.5 cm). Unpublished.
Printer: the artist and his wife, Ada Nolde, Berlin. Edition: approx. 20–30.
The Museum of Modern Art, New York. Given anonymously (by exchange), 1956

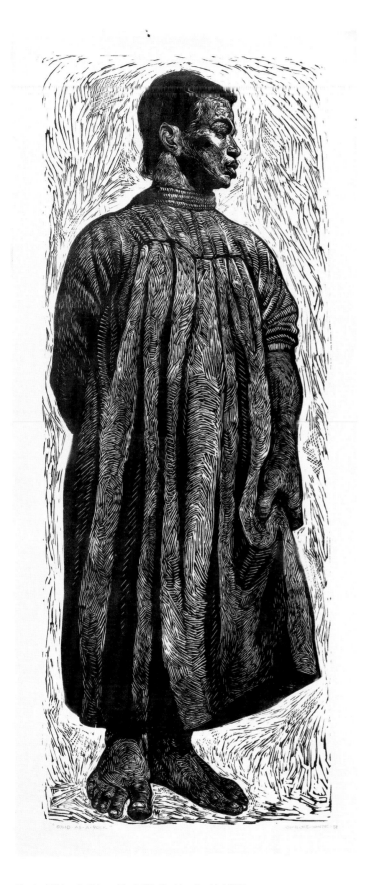

Charles White. *Solid as a Rock (My God Is a Rock)*. 1958.
Linoleum cut, 41⅛ x 17¹³/₁₆ in. (104.5 x 45.2 cm). Unpublished.
Printer: the artist, Los Angeles. Edition: 5 known examples.
The Museum of Modern Art, New York. John B. Turner Fund with
additional support from Linda Barth Goldstein and Stephen F. Dull, 2010

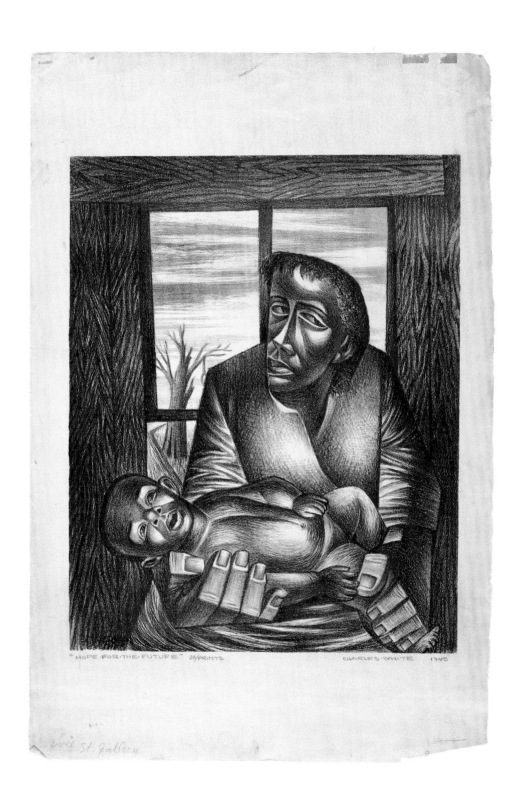

Charles White. *Hope for the Future*. 1945.
Lithograph, 18⁷⁄₈ x 12¹¹⁄₁₆ in. (48 x 32.3 cm). Publisher: the artist.
Printer: unknown. Edition: 20. The Museum of Modern Art, New York.
John B. Turner Fund, 2013

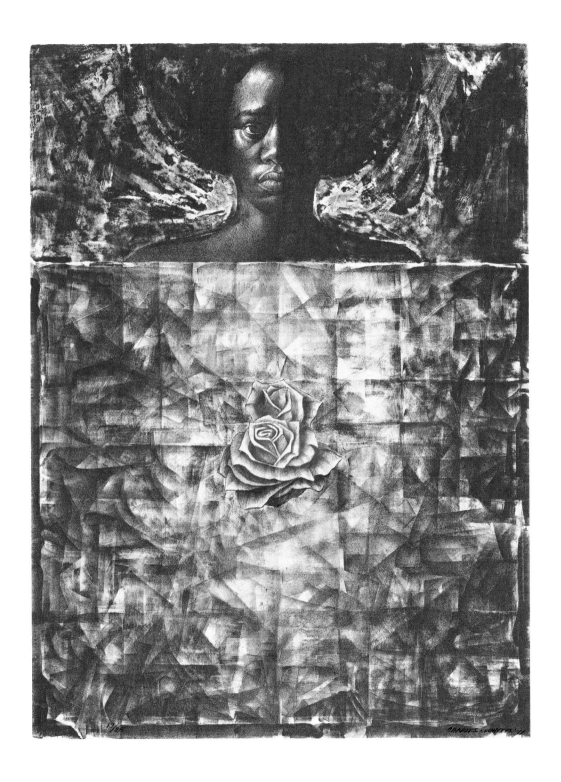

Charles White. *Love Letter #1*. 1971.
Lithograph, 30 1/16 x 22 3/8 in. (76.4 x 56.8 cm).
Publisher and printer: Tamstone Group, Los Angeles. Edition: 25.
The Museum of Modern Art, New York. John B. Turner Fund, 2013

than twenty years after her arrest and imprisonment, wrote, "It is both humiliating and humbling to discover that a single generation after the events that constructed me as a public personality, I am remembered as a hairdo." The photographs of her on FBI wanted posters, and on the cover of *Life* magazine in September 1970, she went on, "served as generic images of Black women who wore their hair 'natural.' . . . the photographs identified vast numbers of my Black female contemporaries who wore naturals (whether light- or dark-skinned) as targets of repression. This is the hidden historical content that lurks behind the continued association of my name with the Afro."[65] *Love Letter #1* can be understood not only in light of these realities but as a response to them. An engaged consumer of published images, White was undoubtedly aware of Davis and of her involuntary role as a visual icon. Although *Love Letter #1* is not a portrait of Davis, as a positive, subtly sanctifying image of a black woman with Davis's natural hair it directly counters the distrust and distortion attached to the FBI posters and sensationalizing media photographs of her.

Black Pope . . . extends this link between politics and religion. Beyond the work's title, and the cross the man wears on his head, his peace-sign gesture is also a version of what in older Christian images is a sign of blessing (above).[66] The striped vertical plane behind him recalls a church banner; the skeleton in front of it, its existence and positioning in real space uncertain, may refer to the crucified body of Christ and is also a memento mori, a meditation on the ultimate demise of all mortals regardless of race. A few years earlier, Robert Rauschenberg had included an x-ray

Hans Memling (German, worked in Flanders, c. 1430 or 1440–1494). *Christ Blessing*. 1481. Oil on panel, 13¹³/₁₆ x 9⅞ in. (35.1 x 25.1 cm). Museum of Fine Arts, Boston. Bequest of William A. Coolidge

image of his own skeleton in his 1967 lithograph *Booster* (right). Created at the Gemini workshop in Los Angeles, *Booster* had been widely admired. White had himself printed at Gemini in 1966 and 1967; he was surely aware of this work.[67] And if Rauschenberg inserted himself into his picture through the use of his own x-ray, White's placement of a skeleton below the stenciled word "CHICAGO" (opposite)—the artist's hometown, the city that had formed and shaped him—suggests a similarly personal intervention, and the making of a connection between the beginnings of a man's life and a universal symbol of life's end.

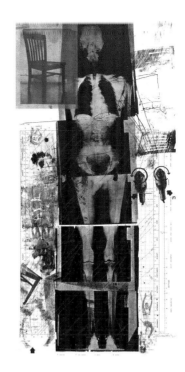

The sandwich board is another of White's additions to Freed's photograph. Capitalized and centered on the sign is the word "NOW"—but "NOW" what? Sandwich boards, which date back to the nineteenth century, were and are often used in commercial advertising. They were also used by the civil rights demonstrators of the 1960s, who wore their demands on their bodies.[68] White builds on this dual lineage by obfuscating his figure's message, subverting our efforts to pin a single meaning to the work even as he encourages us to try. On the one hand the sandwich board implies commodification—"NOW ON SALE!," it might once have read— turning its wearer into a walking advertisement. In this respect it is a contemporary trace of the cruelly detached valuation of black bodies as property during the centuries of slavery.[69] On the other hand, it could be a message of protest: "FREEDOM NOW!" White initially considered including more text on the board, but settled on a single powerful word: a demand, a command, an urgency (opposite).[70] The sandwich board, drawing our attention but open for interpretation, is one of the most striking elements of the work, and a departure from the unambiguous messages communicated by White's "images of dignity." If the figure wearing it, with his shades and sideways view, does not speak to us directly, his sandwich board surely does, although it gives no more than a clue to how the conversation might go.

Robert Rauschenberg (American, 1925–2008). *Booster* from the series Booster and 7 Studies. 1967. Lithograph and screenprint, 72 3/16 x 35 9/16 in. (183.4 x 90.4 cm). Publisher and printer: Gemini G.E.L., Los Angeles. Edition: 38. The Museum of Modern Art, New York. John B. Turner Fund, 1967

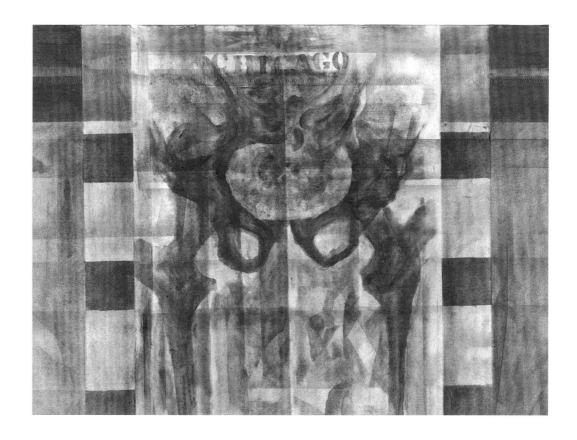

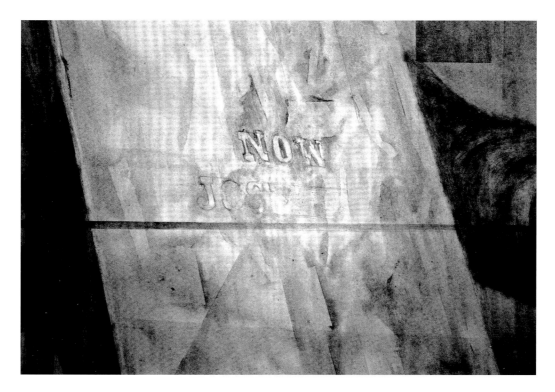

Charles White. *Black Pope (Sandwich Board Man)* (detail)

Charles White. *Black Pope (Sandwich Board Man)* (detail).
Reflected infrared digital photograph

By leaving his message open, White allows much of the meaning of the work to be determined by his audience. This strategy, which he used increasingly in the later part of his career, is reflected in his increasing use of abstract fields as backgrounds for his realistically drawn figures; it is also supported by his chosen medium. By the time of *Black Pope . . .* White had fully mastered the self-invented oil-wash technique that is a signature of his later art. After drawing the major elements of a work on translucent drafting paper he would transfer them to his preferred surface, usually paper mounted on board. Then he would apply diluted oil paint to the paperboard with a variety of implements, creating monochromatic images in shades of burnt umber, building tone layer by layer and developing forms progressively from light to dark.[71] "I very often abuse a surface harshly," he said in 1971, "since I scrub into it with rags and a lot of tools. For instance, in my monochromatic oil drawings, I use Q-tips, Kleenex, rags, balsa wood, brushes, and a whole slew of other things besides—all in one given work."[72]

A study for *Black Pope . . .* (opposite) demonstrates how the transfer process worked. Drawn in graphite and crayon on translucent paper, the figure's head and upper body are distinguished by a darker medium, probably pastel, that has been applied to the back of the sheet.[73] By laying the study on the surface of the final work and then retracing his drawing, the artist transferred elements of his initial composition as pastel lines to the new board. This served as an initial outline before the application of the thinned oil paint. Differences between the study and the final work, both minor (the drape of the pope's headdress, the size and position of the sandwich board) and significant (the move of the knee joint of the skeleton's left leg upward and to the right), show White adjusting his composition as the work progressed.

White first used this oil-wash technique in the Wanted Poster Series, begun in 1969. Inspired by pre–Emancipation posters naming enslaved African Americans who had escaped as fugitives, and advertising auctions where they were bought and sold, the series comprises eighteen drawings and lithographs that reference the historical trauma of slavery and link that history with the present day.[74] Fully modeled figures emerge from complex fields that in composition and palette recall the old posters, folded, creased, and stained. The original posters were only marginally descriptive in visual terms; if they included an image at all, it was generally a stock illustration, often of a man on the run, carrying his belongings on his back. Details were provided by a brief verbal account of his appearance or distinguishing characteristics.[75] This

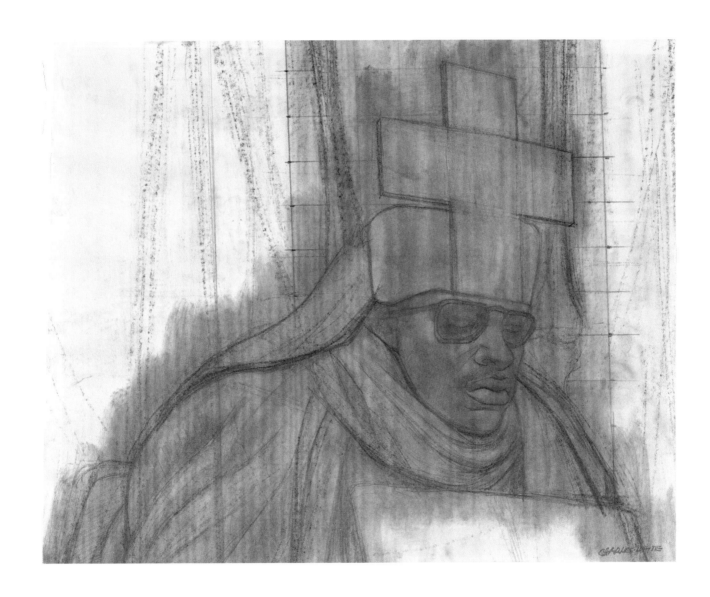

Charles White. Study for *Black Pope*. c. 1973
Graphite, pastel, and crayon on transparentized paper, 17½ x 21¾ in. (44.4 x 55.2 cm).
The Museum of Modern Art, New York. Acquired through the generosity of
Kathy and Richard S. Fuld, Jr., in honor of Esther Adler. 2017

contradiction between the vague stereotype of the picture and the specificity of the text (the posters, after all, were intended to enable a person's identification) has influenced other artists: each of the ten lithographs in Glenn Ligon's 1993 portfolio *Runaways*, for example, pairs a historical image of a fleeing figure with a verbal description of Ligon provided by his friends. Thus a generic figure becomes, for example, "socially very adept, yet, paradoxically, he's somewhat of a loner" (right). Ligon's wanted posters point to, among other things, the inability of language to describe anyone definitively.

If Ligon critiqued the texts of the posters, White, working two decades earlier, upended their visual tropes. Where they had used simplified images of the enslaved, endlessly repeatable and thus dehumanizing, his detailed images show particularized if anonymous individuals. *Wanted Poster Series #17* (1971; opposite), for example, presents a black mother and child. The two figures gaze downward dejectedly, trapped between two columns of text that list a series of names and ages, such as "Harriet 30" or "Asa 8"—descriptive information typical of the historical wanted posters. A bald eagle, majestic symbol of the United States, hovers above them; a horizontal band of dark stars in the picture's center, and lighter stripes throughout the composition, suggest the country's flag. These symbols of America's ambitions—the eagle, the flag—are juxtaposed with a sign of its worst crime: printed above the two black figures is the word "SOLD." That the realistically described woman and child might be living in the America of the 1960s as much as of the 1860s is a reminder of slavery's ongoing legacy.[76]

The layered washes of thinned oil paint in this work produce figures that feel solid and fully realized, yet simultaneously slip back and forth into an unstable background. While the woman's strong hands sit firmly on her son's shoulders, her own left shoulder almost disappears into an area of mottled form, as if pulled back into space, or dissolving into it. The figures are the most clearly delineated elements of the composition yet are embedded in layers of abstract form that in places threaten to submerge them. What allowed White to convey this sense of instability was his oil-wash technique, with its layering of tones so that they refuse to settle into a solid ground. Applied to the theme of the Wanted Poster Series, this instability suggests the trauma of slavery. For scholar Kellie Jones, these abstract "faceted surfaces" produce a "transhistorical space, one where the past and present collide, shift, pass each other by, and coexist. These are not the history paintings that White was known for at the

Glenn Ligon (American, born 1960). Untitled from *Runaways*. 1993. One from a portfolio of ten lithographs, 16 x 12 in. (40.7 x 30.5 cm). Publisher: Max Protetch Gallery, New York. Printer: Burnet Editions, New York. Edition: 45. The Museum of Modern Art, New York. The Ralph E. Shikes Fund, 1993

Charles White. *Wanted Poster Series #17*. 1971. Oil wash and pencil on board, 60 x 30 in. (152.4 x 76.2 cm). Flint Institute of Arts, Flint, Michigan. Gift of Mr. and Mrs. B. Morris Pelavin

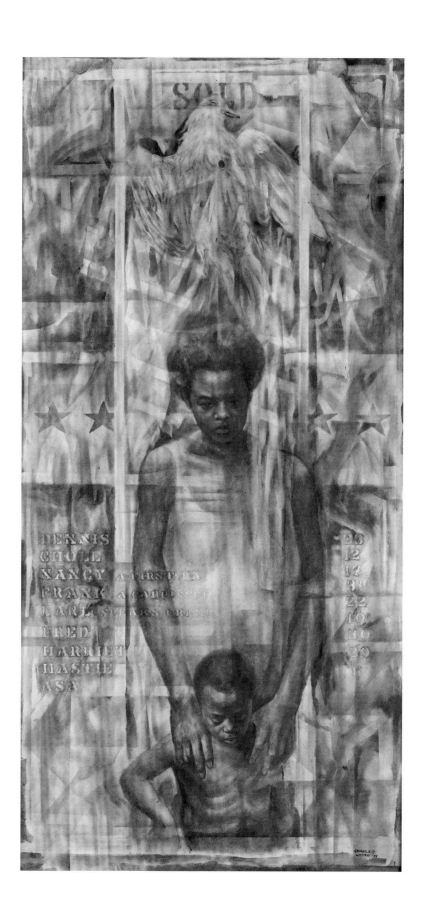

beginning of his career—featuring heroes from an earlier moment with much to tell us about our own time—but works where the past and present inform each other on the physical plane of the picture itself."[77]

The series also speaks to a negotiation between abstraction and representation that had been on White's mind for his entire career. In an interview in 1967, he mentioned a time when "there was a great deal of indecision as to which way I wanted to go, whether to become more abstract. . . . Then I began to concentrate on making a person look like a person. Basically, I'm a realistic painter and I can't apologize for being a realistic painter."[78] White's embrace of figuration, though, did not forestall an interest in and in fact an admiration for other approaches. Living in New York's Greenwich Village in the 1940s, he engaged with Abstract Expressionist artists including Jackson Pollock, Adolph Gottlieb, Franz Kline, and Willem de Kooning, and he would later credit them with helping to expand his thinking about how to solve formal problems.[79] This appreciation of art unlike his own continued throughout his career:

I like particularly the paintings of Morris Louis . . . most of [Mark] Rothko's work [is] extremely exciting to me, Jasper Johns, [Roy] Lichtenstein, I have found very interesting. That is to say, our tastes are very catholic, that is to say, very broad and inclusive. I look to art for what I can learn from it. . . . I don't have to accept in totality the idea behind it, you understand, content wise, or the philosophy behind it. But I find if it's competent, if they have explored new ideas, they are related to the same problems that I have. Despite the fact that I might approach a piece of work in a representational manner. I'm dealing with all the formal problems relating to doing a picture, and most of these problems are very abstract. They're very elusive problems and very difficult.[80]

Clearly White considered a wide range of art as being in conversation with his practice and was open to ideas that might seem incongruent with his. He even embraced certain elements of these approaches, notably the use of abstract areas in such works as the Wanted Poster Series. The multiple layers he created with the oil-wash technique often seem to conceal recognizable imagery, hidden within what at first seem to be random planes and shapes. The device calls forth a close looking that reflects White's efforts to engage with his audience in new ways within a practice still representational at heart.

White continued to employ the oil-wash technique and palette in many of the works that followed the Wanted Poster Series. *Harriet X* (1972–73; opposite), for

Charles White. *Harriet X*. 1972–73.
Oil wash on board, 65 x 45 in. (165.1 x 114.3 cm).
Collection Thomas and Almera Lewis

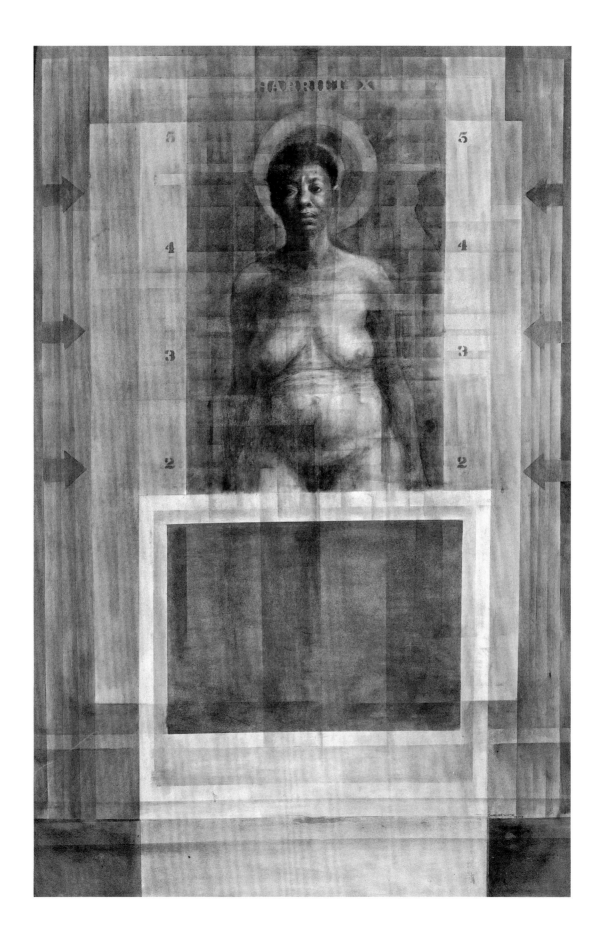

example, shares elements with *Wanted Poster #17*, such as the placement of the figure within a central vertical field (a structure also shared with *Black Pope . . .*) and the inclusion of stenciled text, the woman's name directly above her head. Several details evoke a slave auction, such as the numbers and arrows to the sides—as a measurement aid, these would allow a buyer to determine the woman's height—and the large solid square, probably an auction block, in front of her lower body. The woman's first name references Harriet Tubman, who led many African Americans to freedom on the Underground Railroad; White had depicted Tubman several times over the years.[81] The use of an *X* as her surname recalls the practice among members of the Nation of Islam of repudiating the name given to them in the slave system by renaming themselves "X" (the Nation's best-known member, of course, was Malcolm X).[82] The name also echoes the title of *Pope X*, the etching from the same period, where X is the roman numeral attached to a papal name.[83] This complexity is embodied in the figure herself: even naked and presented as if for sale, she shows enormous composure and an unshakable sense of self, meeting the viewer's gaze head-on. The target behind her head encourages further interpretations, warning of violence, of danger, but also acting as a halo of sorts. This and the auction-block-like form, which might also be a pulpit, reintroduce White's religious sensibility, casting Harriet X as a martyr or saint.

The target further suggests a nod to Jasper Johns, whom we have seen White saying he found "very interesting." Johns's best-known early work was a target painting—*Target with Four Faces* (1955; above), which had appeared on the cover of *Artnews* magazine in January 1958—and he produced many such images, famously terming the target one of the "things the mind already knows."[84] White for his part also included a target in other works, such as the 1972 oil painting *Homage to Sterling Brown* (opposite), which shows Brown, a poet and a scholar of Southern black culture, wearing dark glasses and with a flat target superimposed on his chest. In this context the target might at first seem to imply the violence often aimed against African Americans, but White's targets, like Johns's, are hard to pin down. In *Homage to Sterling Brown*, the floating target seems stamped on the surface of the image, existing in a different space from the figure and in contrast to the densely layered imagery behind him, which reflects White's more typical weaving of letters and images amid planes, tones,

Jasper Johns (American, born 1930). *Target with Four Faces*. 1955. Encaustic on newspaper and cloth over canvas surmounted by four tinted-plaster faces in wood box with hinged front, 33⅝ x 26 x 3 in. (85.3 x 66 x 7.6 cm). The Museum of Modern Art, New York. Gift of Mr. and Mrs. Robert C. Scull, 1958

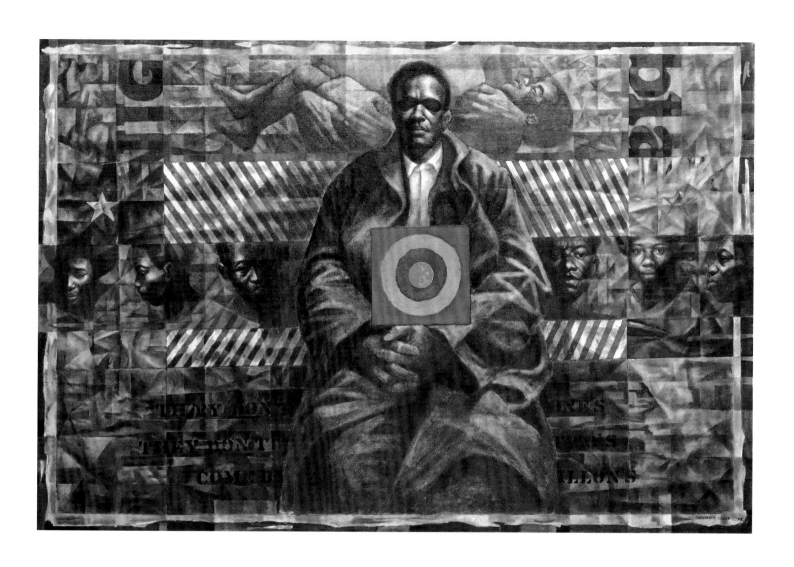

Charles White. *Homage to Sterling Brown*. 1972.
Oil on canvas, 40 x 60 in. (101.6 x 152.4 cm).
Blanton Museum of Art, The University of Texas at Austin. Gift of
Susan G. and Edmund W. Gordon to the units of Black Studies and
the Blanton Museum of Art and the University of Texas at Austin

and stripes. This target announces itself, and the painting as a whole, as not simply a descriptive portrait of Sterling Brown but an aesthetic construction by Charles White.

In these and other works from the late 1960s and '70s we see a balancing act: White's adoption of increasingly complex visual strategies in dialogue with the art of his time, and at the same time his honoring of his commitment to making pictures accessible to his audiences. One of his strategies was the use of common symbols—the roses in *Love Letter #1*, the eagle in *Wanted Poster Series #17*, the peace sign in *Black Pope* . . . —and their placement in rich contexts through the use of his oil-wash technique, which produced complex backgrounds that themselves imply but don't specify further meanings.

BLACK POPE IN THE TWENTY-FIRST CENTURY

In February 2005, Marshall included *Black Pope* . . . in a pendant show to a traveling exhibition of his own work, *Kerry James Marshall: One True Thing, Meditations on Black Aesthetics*. Marshall's aim, a wall text explained, was "to honor those artists who have mentored and taught others while developing their own successful careers as practicing artists."[85] White fit this bill on all fronts, having mentored Marshall since the younger artist began sitting in on his classes at Otis as a seventh-grader. Marshall officially enrolled in the school in 1977, when he was in his early twenties, so that he could continue to study with White. The two artists share a dedication to painting images of black people into histories of both art and the United States, as well as into popular consciousness (below).

Marshall admires White's work generally, but his feeling for *Black Pope* . . . is quite specific:

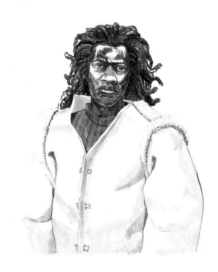

Apart from the kind of sheer power in the rendering of that figure, in some ways you could make the case that it was a more total picture. . . . there were more elements in the picture overall that had to be managed and taken account of, that had to be composed. . . . It wasn't so much a figure-ground kind of thing but a figure as a shape within a constellation of shapes. So that was one of the things that made it such a powerful picture—it just seemed so complete.[86]

Kerry James Marshall (American, born 1955). *Untitled (Stono Drawing)*. 2012. Watercolor, ink, and pencil on paper, 31¾ x 25 in. (80.6 x 63.5 cm). The Museum of Modern Art, New York. Acquired through the generosity of Thelma and AC Hudgins, Donald B. Marron, and Susan G. Jacoby in honor of her mother, Marjorie L. Goldberger, 2013

Marshall continued, "The reason why works like these seem so complete to me is in part because I think [White] was more and more invested in the kind of pictorial enterprise, in making good pictures, and less and less interested in the specificity of how these figures might function as a symbol of something."[87] By the last decade of his career, White was pushing the boundaries of what was expected both of him and of representational art. Using strategies embedded in contemporary art, he turned them to his own ends.

Yet knowing White's history of concern with the social and political, we cannot doubt that *Black Pope (Sandwich Board Man)* has deep symbolic meaning. The artist said of himself in the 1978 interview, "For me, the thing that matters most is not the form per se, but the depth of the content. I may experiment with new compositional forms, but my chief concern is always with expressing a particular feeling or emotion."[88] That it is difficult to ascribe a singular feeling or emotion to *Black Pope . . .* , or to definitively explain the message or mission of its central figure, speaks to White's success in addressing the American psyche of its day, and of our own. If we today find the work difficult to define, the drawing demands that we try. The "NOW" at the heart of *Black Pope (Sandwich Board Man)* reflects the artist's hope and belief that we will succeed on our own terms, and, by extension, that the power of art will effect meaningful change.

NOTES

1. Charles White, quoted in Jeffrey Elliot, "Charles White: Portrait of an Artist," *Negro History Bulletin* 41, no. 3 (May–June 1978):828.

2. David Hammons, quoted in Joseph E. Young, *Three Graphic Artists: Charles White, David Hammons, Timothy Washington*, exh. cat. (Los Angeles: Los Angeles County Museum of Art, 1971), p. 7. White's work has continued to be a touchstone for Hammons, who has recently conceived of a project centered on *Black Pope (Sandwich Board Man)*, to be presented at The Museum of Modern Art from October 2017 to January 2018.

3. Ibid.

4. Kerry James Marshall, in "An Argument for Something Else: Dieter Roelstraete in Conversation with Kerry James Marshall, Chicago 2012," in *Kerry James Marshall: Painting and Other Stuff*, exh. cat. (Antwerp: Luidon, 2013), p. 21.

5. Benjamin Horowitz, "Images of Dignity," in *Images of Dignity: The Drawings of Charles White* (Los Angeles: The Ward Ritchie Press, 1967), p. 7.

6. Two recent books that focus on artists' engagement with the Great Migration are Sarah Kelly Oehler, *They Seek a City: Chicago and the Art of Migration 1910–1950*, exh. cat. (Chicago: The Art Institute of Chicago, 2013), and Leah Dickerman and Elsa Smithgall, *Jacob Lawrence: The Migration Series*, exh. cat. (New York: The Museum of Modern Art, and Washington, D.C.: The Phillips Collection, 2015). See also the MoMA website accompanying the 2015 exhibition *One-Way Ticket: Jacob Lawrence's Migration Series*, online at www.moma.org/interactives/exhibitions/2015/onewayticket/ (accessed January 2017).

7. See Andrea D. Barnwell, *Charles White*, The David C. Driskell Series of African American Art 1 (San Francisco: Pomegranate, 2002), p. 12.

8. See Erik S. Gellman, "Chicago's Native Son: Charles White and the Laboring of the Black Renaissance," in Darlene Clark Hine and John McCluskey, Jr., eds., *The Black Chicago Renaissance* (Urbana: University of Illinois Press, 2012), pp. 149–57. For recollections of White's education and social networks in Chicago see Eldzier Cortor, "He was at home creatively in any locale," and Margaret G. Burroughs, "He will always be a Chicago artist to me," *Freedomways* 20, no. 3 (1980):149–54.

9. Although generally called White's first mural, *Five Great American Negroes* is not painted directly on an architectural facade. It is a free-standing painting in oil on canvas, measuring five feet high and almost thirteen feet long.

10. "Washington Tops List of Race Leaders," *The Chicago Defender*, national ed., October 14, 1939, p. 23. Founded in 1905, *The Chicago Defender* was and is an influential black newspaper.

11. As a schoolboy, White discovered historical figures such as those shown in *Five Great American Negroes* through his own research, then was discouraged by his teachers from discussing them at school. See, e.g., his interview with Peter Clothier, September 14, 1979, p. 29, quoted in Lucinda H. Gedeon, "Introduction to the Work of Charles W. White with a Catalogue Raisonné," MA thesis, University of California, 1981, p. 52 n. 20. Partial transcripts of this and other interviews are held by the Charles White Archives and can also be found in Lucinda H. Gedeon, research material on Charles W. White (c. 1977–97), Archives of American Art, Smithsonian Institution, Washington, D.C.

12. Founded in 1941, the South Side Community Art Center is a now legendary institution that has provided exhibition space for African-American artists since its earliest years. It has also organized projects by an international range of artists and has offered classes taught by an equally diverse staff. It remains active today, the only formerly WPA-supported center still in operation.

Its cofounders included White, Henry Avery, Margaret G. Burroughs, William Carter, Eldzier Cortor, and Archibald Motley, Jr. See Oehler, *They Seek a City*, p. 40, and Anna M. Tyler, "Planting and Maintaining a 'Perennial Garden': Chicago's South Side Community Art Center," *The International Review of African American Art* 11, no. 4 (1994):31–37.

13. Dorothy Miller, letter to Fred Biesel, November 10, 1941. Department of Painting and Sculpture: Artists Records, I.347, Charles White, The Museum of Modern Art Archives, New York. I thank my colleague Charlotte Barat, in the Department of Painting and Sculpture, for pointing me toward this letter and for sharing her research into the Museum's history with black artists.

14. See Daniel Schulman, "African American Art and the Julius Rosenwald Fund," in Schulman, ed., *A Force for Change: African American Art and the Julius Rosenwald Fund* (Chicago: Spertus Institute of Jewish Studies, 2009), pp. 65, 78 n. 49. Different titles have been assigned to this mural. The artist, in his application for a fellowship from the Julius Rosenwald Fund, called it *Struggle for Liberation*. See Special Collections, Charles W. White Rosenwald Fellowship, John Hope and Aurelia E. Franklin Library, Fisk University. I thank my colleague Sarah Kelly Oehler at The Art Institute of Chicago for sharing this material with me. Gedeon, in "Introduction to the Work of Charles W. White," p. 64, A4, calls the left-hand panel *Revolt of the Negro during Slavery*. Barnwell, in *Charles White*, p. 26, and Gellman, in "Chicago's Native Son," p. 155, refer to the complete work as *Chaos of the American Negro*. In her book *The Other Blacklist: The African American Literary and Cultural Left of the 1950s* (New York: Columbia University Press, 2014), pp. 82–83, Mary Helen Washington uses the title *Techniques Used in the Service of Struggle*, and suggests that the several titles cited for the work may indicate a discomfort with its imagery. According to Schulman, the title *Chaotic Stage of the Negro, Past and Present* appeared in an article of May 1940 in the *Chicago Bee*. I have used this title since it appears in an account published at the time.

15. Miller's reasons for leaving *Chaotic Stage of the American Negro . . .* out of *Americans 1942 . . .* are unclear from the documents in the MoMA Archives. In her letter to Biesel of November 10, 1941, Miller asks whether the work would already be permanently installed in Chicago by the time her show opened. Replying two days later, Biesel noted, "If the invitation to exhibit the mural at the Museum of Modern Art is forthcoming there is very little doubt but that we can delay its installation." Biesel, letter to Miller, November 12, 1941. Department of Painting and Sculpture: Artists Records, I.347, Charles White, The Museum of Modern Art Archives, New York. The work's large dimensions were also a challenge: Miller expresses concern over them in her letter to Biesel, and installation photographs of the eventual exhibition show no other works even close to its size. Both of these issues would have been moot, however, if the work was never finished. Miller asked Biesel, "Could you let me know right away whether the mural has been completed, or would be completed about the first of January," but Biesel's response includes no answer to this question. A photograph shows White working on the left-hand panel of the mural (p. 16), and a study shows his complete plan for the work (pp. 14–15), but no image is known showing the actual right-hand panel. Nor was the painting ever installed in the Chicago library for which it was intended. See Schulman, ed., *A Force for Change*, p. 78 n. 49.

16. See Barnwell, *Charles White*, pp. 6–12.

17. *The Contribution of the Negro to Democracy in America* is reproduced in ibid., pp. 32–33.

18. Like many American artists of his generation, White admired the Mexican muralists. Not only had he seen their work at The Art Institute of Chicago but two of his fellow muralists at the WPA, Mitchell Siporin and Edward Millman, had worked directly with them in Mexico and had described their experiences there to him. See Barnwell, *Charles White*, p. 26, and Oehler, *They Seek a City*, pp. 53–58.

19. "Due to war regulations affecting travel and the refusal of my draft board to permit me to leave the country," White wrote in 1943, "it was necessary for me to deviate from my original plan to study fresco and tempera painting in Mexico." White, "Report of a Year's Progress and Plan of Work for a Renewal of a Julius Rosenwald Fellowship," Reel 3193, Charles W. White papers, [c. 1930]–1982, Archives of American Art.

20. On White's life in the 1940s see Barnwell, *Charles White*, pp. 27–39, 108–9; on the influence of Mexico and the muralists on his work see Lizzetta LeFalle-Collins and Shifra M. Goldman, *In the Spirit of Resistance: African-American Modernists and the Mexican Muralist School*, exh. cat. (New York: The American Federation of Arts, 1996).

21. White, quoted in John Pittman, "He was an implacable critic of his own creations," *Freedomways* 20, no. 3 (1980):191.

22. See Washington, *The Other Blacklist*, pp. 89–100.

23. White, quoted in Horowitz, "On the Road with Charlie White," *Freedomways* 20, no. 3 (1980):164. While the claim is questionable (there are books on Jacob Lawrence, for example, that predate 1967), a serious publication of this length and production quality on the work of a single black artist was certainly a rarity at the time.

24. When this work was auctioned at Leslie Hindman Auctioneers in 1994, it was erroneously titled *Bayou Scene and Man in Chains*. It is signed and titled *The Preacher* on the back, however. See Artnet Fine Arts Auction Database, online at http://www.artnet.com/PDB/FAADSearch/LotDetailView.aspx?Page=2&artType=FineArt&subTypeId=11 (accessed May 5, 2017).

25. White's mural *A History of the Negro Press* (1940; repr. in Barnwell, *Charles White*, p. 9) implicitly links reading and writing with empowerment. A man on the left-hand side of his mural *Chaotic Stage of the Negro, Past and Present* (pp. 14, 16) holds a book aloft, and a man at a podium above him is reading from a book. That second figure is probably a preacher; in White's color study for the mural the podium bears the text "GOD IS LOVE," although that detail is absent in the single black and white photograph we have of the work in progress. Washington discusses the symbolism of White's inclusion of books and a preacher in this work; see *The Other Blacklist*, pp. 83–84.

26. See Barnwell, *Charles White*, pp. 13–15, and Betty Hoag, "Oral history interview with Charles Wilbert White," March 9, 1965, Archives of American Art. Available online at www.aaa.si.edu/collections/interviews/oral-history-interview-charles-w-white-11484 (accessed July 9, 2017).

27. On the importance of preaching in African American culture see Dale P. Andrews, "African American Preaching and Sermonic Traditions," in Anthony B. Pinn, ed., *American Religious Cultures: African American Religious Cultures* (Santa Barbara: ABC-CLIO, 2009), 2:477.

28. White, Artist Questionnaire, May 17, 1952, 52.25, Permanent Collection Documentation Office, Whitney Museum of American Art, New York. Of note here is the final sentence of White's statement: "I intend to do other drawings and paintings developing this theme further and even more concretely."

29. "The Charge IS Genocide," *Freedom* II, no. 1 (February 1952):1. Gedeon lists the work as "*The Preacher* or *Paul Robeson*." Gedeon, "Introduction to the Work of Charles W. White," p. 141, D72. On White's relationship with Robeson see Barnwell, *Charles White*, p. 34, and Washington, *The Other Blacklist*, pp. 89–93.

30. See Barnwell, *Charles White*, p. 34.

31. See "Chronology," in Jeffrey C. Stewart, ed., *Paul Robeson: Artist and Citizen* (New Brunswick: Rutgers University Press and the Paul Robeson Cultural Center, 1998), p. xxxiii.

32. Washington explores the underlying meanings of other of White's works from the 1950s in her excellent chapter "Charles White: 'Robeson with a Brush and Pencil,'" *The Other Blacklist*, pp. 69–122, esp. pp. 110–15.

33. See ibid., p. 95, and Barnwell, *Charles White*, pp. 50–51.

34. White, quoted in Elliot, "Charles White: Portrait of an Artist," p. 828.

35. Ibid.

36. Leonard Freed, *Black in White America* (New York: Grossman Publishers, [1969]), p. 29. White's study for *Black Pope . . .* (p. 43) shows a grid of faint ruled lines around the pope's head and hat. Grids have long been used in copying images; it is unclear how or whether White used this grid, however, as no grid appears on the photograph in his copy of Freed's book.

37. Marshall sent a scan of Freed's photograph to me by e-mail on July 6, 2016. C. Ian White looked for and found his father's copy of Freed's book soon after, and kindly made it available to me.

38. See "Leonard Freed," *Infinity* XVI, no. 10 (October 1967):9, and "News: Black in White America," Grossman Publishers, New York, 1969, in the Leonard Freed artist's file, The Museum of Modern Art Library.

39. Freed's text for *Black in White America* is interspersed among the book's photographs, and it is not always clear which phrases refer to which images. A text about Raleigh appears on the spread following the photograph of the preacher, leading me to the supposition that the photograph was taken there.

40. Freed, *White in Black America*, pp. 54–55, 132, 145.

41. Traces of an earlier placement of the left hand, about an inch closer to the work's edge, can be made out in the drawing.

42. During World War II, the weekly *Pittsburgh Courier*, then a prominent black newspaper, had launched a national "Double V" campaign calling for victories in both the war abroad and the war against racism at home. White would surely have been aware of that campaign, and although its visual legacy was a logo rather than a hand gesture, the two-fingered "peace" sign may have had that resonance for him.

43. See, e. g., Maurice Isserman and Michael Kazin, *America Divided: The Civil War of the 1960s*, 2000 (fourth ed. New York: Oxford University Press, 2012), pp. 62–96, 247–88.

44. James Reston, "War Leaves Deep Mark on U.S." *New York Times*, January 24, 1973, pp. 1, 17.

45. John Sibley Butler, "African Americans in the Military," *The Oxford Companion to American Military History* (Oxford University Press, 2000, published online 2004); web version accessed by the author November 14, 2016.

46. See Barnwell, *Charles White*, p. 35.

47. See Louie Robinson, "Charles White: Portrayer of Black Dignity," *Ebony* XXII, no. 9 (July 1967):30.

48. White, quoted in Elliot, "Charles White: Portrait of an Artist," p. 827.

49. Peniel E. Joseph, "Foreword: Reinterpreting the Black Power Movement," *OAH Magazine of History* 22, no. 3, "Black Power" issue (July 2008):6.

50. Erika Doss, "Imaging the Panthers: Representing Black Power and Masculinity, 1960s–1990s," *Prospects: An Annual of American Studies* 23 (1998):489.

51. Henry Louis Gates, Jr., quoted in ibid., p. 490.

52. Doss, "Imaging the Panthers," p. 497, quoting Emory Douglas from 1969. Ironically, Douglas's own work seems in time to have moved closer to

White's: "'his art shifted from inflammatory images of resistance and revolution to the 'loves, joys, hope and dreams of black people in America: the bright side as well as the dark side of life.'" Ibid., p. 508, quoting an interview with Douglas in 1993.

53. White, quoted in Elliot, "Charles White: Portrait of an Artist," p. 827. White also insists here on both the universality of his imagery and his focus on "love, hope, courage, freedom, dignity—the full gamut of the human spirit."

54. See Barnwell, *Charles White*, p. 92, and Kellie Jones, *Now Dig This! Art and Black Los Angeles 1960–1980*, exh. cat. (Los Angeles: Hammer Museum, 2011), pp. 140–41. Angela Davis was fully acquitted in 1972.

55. Robert Doty, *Contemporary Black Artists in America*, exh. cat. (New York: Whitney Museum of American Art, 1971), pp. 26, 28.

56. Richard J. Powell, *Cutting a Figure: Fashioning Black Portraiture* (Chicago: The University of Chicago Press, 2008), p. 161.

57. The video, in the Charles White Archives, is clearly a clip from a longer program and the brief appearance in it of the artist and curator David Driskell suggests that it may have been made in conjunction with the exhibition *Two Centuries of Black American Art*, which Driskell organized for the Los Angeles County Museum of Art in 1976. There is a drawing in the Arthur Primas collection, described as *Study for Pope X*, that relates to the one seen in the video; see *Heroes: Gone but Not Forgotten* (Los Angeles: Heritage Gallery/ Landau Traveling Exhibitions, 2012), pp. 45–46. That work is dated c. 1960, but given its similarity to the work in the video, a later date seems more likely.

58. *Time* described Philip Alford Potter as the "ecumenical spokesman for . . . some 400 million Christians in all. Since Protestants form the core

of the organization, he will become (though in a vastly less powerful way than Rome's Pontiff) the Protestant 'pope.'" *Time* 100, no. 9 (August 28, 1972):81.

59. Sam Uba, "An African Pope?," *Encore* 2, no. 8 (August 1973):44–46.

60. See Kymberly N. Pinder, "'Our Father, God; Our Brother, Christ; or are we bastard kin?': Images of Christ in African American Painting," *African American Review* 31, no. 2 (Summer 1997):223–33, and Pinder, "Deep Waters: Rebirth, Transcendence, and Abstraction in Romare Bearden's Passion of Christ," in Ruth Fine and Jacqueline Francis, *Romare Bearden, American Modernist* (Washington, D.C.: National Gallery of Art, 2011), pp. 145–65. On the political dimension of African-American religious belief see James Lance Taylor, "African American Religion and Politics," in Pinn, ed., *American Religious Cultures: African American Religious Cultures*, 2:517–31.

61. White often cited the German Expressionist artist Käthe Kollwitz as an inspiration. See Hoag, "Oral history interview with Charles Wilbert White," and Stacy I. Morgan, *Rethinking Social Realism: African American Art and Literature, 1930–1953* (Athens: The University of Georgia Press, 2004), pp. 111–12.

62. White, lettergram to Ruth Hopkins, November 7, 1963, Reel 3193, Charles W. White papers, [ca.1930]–1982, Archives of American Art. It is also worth noting that in the same year White made this print, Robeson released *Solid Rock: Favorite Hymns of My People*, an LP that included the popular hymn "Solid Rock." The chorus of this hymn is "On Christ the solid rock I stand/All other ground is sinking sand." See *Gospel Pearls* (Nashville: Sunday School Publishing board National Baptist Convention, 1921), no. 10. See also "Chronology," in Stewart, ed., *Paul Robeson: Artist and Citizen*, p. xxxiv.

63. For a discussion of works by black artists, including White's *Hope for the Future*, that link the suffering of Christ with that of African Americans see Morgan, *Rethinking Social Realism*, pp. 144–47. See also Reba and Dave Williams, "Themes and Images," in *Alone in a Crowd: Prints of the 1930s–40s by African-American Artists*, exh. cat. (Newark: Newark Museum, 1992), pp. 24–28.

64. "White feels that white Americans can eventually relate to this universality even though it be depicted through black images, just as he has been able to relate to white symbols of universality, 'like the Statue of Liberty.'" Robinson, "Charles White: Portrayer of Black Dignity," p. 30.

65. Angela Y. Davis, "Afro Images: Politics, Fashion, and Nostalgia," *Critical Inquiry* 21, no. 1 (Autumn 1994):37–38, 42.

66. See Leslie Ross, *Medieval Art: A Topical Dictionary* (Westport, Conn.: Greenwood Press, 1996), p. 34, Adolphe Napoléon Didron, *Christian Iconography: The History of Christian Art in the Middle Ages*, 1851 (Eng. trans. E. J. Millington, New York: Frederick Ungar Publishing, 1968), pp. 201–6, and Amanda Schupak, "The Strange Origin of Pope's Gesture of Blessing," CBS News, September 18, 2015, available online at www.cbsnews.com/news/the-strange-origin-of-popes-gesture-of-blessing/ (accessed April 4, 2016).

67. Ken Tyler, a cofounder of Gemini G.E.L., printed White's lithographs *Exodus II* (1966) and *Head* (1967) at his earlier print workshop Gemini Limited.

68. See, e.g., the photograph reproduced on p. 5 of Michael Anderson, *The Civil Rights Movement* (Chicago: Heinemann Library, 2004), or the notorious case of William Lewis Moore, a white postal worker murdered in Alabama in 1963 while wearing sandwich boards demanding equal rights.

69. My thinking on the sandwich board was shaped by Susan Buck-Morss's essay "The Flaneur, the Sandwichman and the Whore: The Politics of Loitering," *New German Critique* no. 39 (Autumn 1986):99–140. I thank Jodi Hauptman, Senior Curator, Department of Drawings and Prints, The Museum of Modern Art, for recommending this essay to me.

70. Close examination of the drawing reveals additional lettering, now obscured, and reflected-infrared digital photographs clarify certain characters—a *J*, perhaps an *S*—as well as ruled lines suggesting the beginning of another word. (Could the original phrase have been "NOW JUSTICE," or "NOW JESUS"?) I am grateful to Laura Neufeld, Assistant Paper Conservator, The Museum of Modern Art, for these photographs and for her valuable thoughts on White's techniques.

71. Analyses of samples of the medium of *Black Pope* confirm that White mixed the oil-paint wash himself—it was not a commercially prepared product. (These analyses were performed by Chris McGlinchey, Sally and Michael Gordon Conservation Scientist, The Museum of Modern Art, June 2016.) According to Marshall, when White taught this technique he began by using turpentine to thin the oil paint significantly. Marshall, conversation with the author, June 2016.

72. White, quoted in Young, *Three Graphic Artists*, p. 5.

73. Media analysis of the work could not be definitively confirmed at the time of the writing of the present essay.

74. Gedeon includes Wanted Poster Series 1–18 in her catalogue raisonné, 1–10 and 16–18 as drawings and 11, 12, 14, and 15 as lithographs. She has no listing for no. 13; perhaps this is *Wanted Poster Series (Cuney Quotation)*, which she lists as Addendum 8. The first six drawings in

the series were also issued in a portfolio, *Wanted Poster Series*, published by the Heritage Gallery in 1970. See Gedeon, *Introduction to the Work of Charles W. White*, pp. 185–89, D255–D267; pp. 353–54, Ea21–Ea24; and p. 437, Addendum 8.

75. See Marcus Wood, *Blind Memory: Visual Representations of Slavery in England and America 1780–1865* (Manchester: Manchester University Press, 2000), esp. pp. 80–94.

76. For reproductions of two more drawings in the Wanted Poster Series see Barnwell, *Charles White*, pp. 89, 91. All of the lithographs that Gedeon identifies as belonging to the series, including two that exist in two states, are in the collection of The Museum of Modern Art (370–375.1970) and are represented on the Museum's website at www.moma.org/artists/6339#works (accessed February 2017).

77. Jones, *South of Pico: African American Artists in Los Angeles in the 1960s and 1970s* (Durham: Duke University Press, 2017), p. 46. For more on these works, and how they fit into White's overall corpus, see Jones's excellent chapter "Emerge: Putting Southern California on the Art World Map," ibid., pp. 23–65.

78. White, quoted in Robinson, "Charles White: Portrayer of Black Dignity," p. 30.

79. White, in "Rap Session CW/RS 70," typescript, The Charles White Archives. There is also a copy in the Gedeon research material on White in the Archives of American Art, Box 2, Folder 2. The interviewer is not identified by name but is referred to as "student."

80. Ibid.

81. A 1965 drawing of White's, for example, is titled *General Moses (Harriet Tubman)*.

82. See C. Eric Lincoln, *The Black Muslims in America*, 1961 (rev. ed. Boston: Beacon Press, 1973), p. 115, and Lawrence. A. Mamiya, "Nation of Islam," in Pinn, ed., *American Religious Cultures: African American Religious Cultures* (Santa Barbara: ABC-CLIO, 2009, and Boston: Credo Reference, 2012); electronic book, accessed November 10, 2016.

83. A faint letter *X* also appears in *Black Pope (Sandwich Board Man)*, centered in the pelvic area of the skeleton.

84. The phrase is much quoted. See Johns, *Jasper Johns: Writings, Sketchbook Notes, Interviews*, ed. Kirk Varnedoe (New York: The Museum of Modern Art, 1996), p. 82.

85. Exhibition wall text, Birmingham Museum of Art, Alabama, 2005, provided to the author by curator Emily G. Hanna. Originally organized at the Museum of Contemporary Art, Chicago, by Elizabeth Smith with Tricia Van Eck, *Kerry James Marshall: One True Thing, Meditations on Black Aesthetics* included one of these pendant shows whenever it traveled. The version that included *Black Pope . . .* was *Giving Honor: Kerry James Marshall, Black Aesthetics, and the Community*, organized by Marshall and Hanna at the Birmingham Museum of Art, February 3–April 24, 2005.

86. Marshall, conversation with the author, June 2016.

87. Ibid.

88. White, in Elliot, "Charles White: Portrait of an Artist," p. 825.

Barnwell, Andrea D. *Charles White*.
San Francisco: Pomegranate, 2002.

Charles White: Art and Soul. Freedomways
20, no. 3 (1980). Special issue.

Charles White: A Retrospective. Exh. cat.
Chicago: The Art Institute of Chicago,
and New Haven: Yale University Press.
Forthcoming in 2018.

Charles W. White Papers. Archives of
American Art, Smithsonian Institution,
[c. 1930]–1982.

Gedeon, Lucinda Heyel. "Introduction to the
Work of Charles W. White with a Catalogue
Raisonné." MA thesis, University of California,
Los Angeles, 1981.

Gellman, Erik S. "Chicago's Native Son:
Charles White and the Laboring of the Black
Renaissance." In Darlene Clark Hine and
John McCluskey Jr., eds. *The Black Chicago
Renaissance*. Champaign: University of Illinois
Press, 2012. Pp. 147–164.

Horowitz, Benjamin. *Images of Dignity:
The Drawings of Charles White*. Los Angeles:
Ward Ritchie Press, 1967.

*Images of Dignity: A Retrospective of
the Works of Charles White*. Exh. cat. New
York: The Studio Museum in Harlem, 1982.

Jones, Kellie. *Now Dig This! Art & Black
Los Angeles 1960–1980*. Exh. cat.
Los Angeles: Hammer Museum, 2011.

———. *South of Pico: African American
Artists in Los Angeles in the 1960s and 1970s*.
Durham: Duke University Press, 2017.

LeFalle-Collins, Lizzetta, and Shifra M.
Goldman. *In the Spirit of Resistance: African-
American Modernists and the Mexican
Muralist School*. New York: American
Federation of Arts, 1996.

Washington, Mary Helen. "Charles White:
'Robeson with a Brush and Pencil.'" In *The
Other Blacklist: The African American Literary
and Cultural Left of the 1950s*. New York:
Columbia University Press, 2014.

White, Frances Barrett, with Anne Scott.
Reaches of the Heart. New York: Barricade
Books, 1994.

Young, Joseph E. "Charles White." *Three
Graphic Artists*. Exh. cat. Los Angeles: Los
Angeles County Museum of Art, 1971.

ACKNOWLEDGMENTS

It has been an honor to spend time looking at Charles White's drawing *Black Pope (Sandwich Board Man)*, not only because of the insight it provides into White's art but because of the incredible community of people it has allowed me to work with. Foremost among them is the artist's son C. Ian White, who maintains the Charles White Archives and who has been unfailingly generous with his time and support for this project. He has been vital to my research and to my thinking about his father's work. White's former students, especially David Hammons and Kerry James Marshall, were also critical to my understanding of their teacher's work and process—I thank them for their sharing their experiences with me, and for their unique insight into his practice and methods.

Kellie Jones, Associate Professor of Art History at Columbia University, served as an outside reader for an early version of my text and provided both encouragement and guidance. Her scholarship and work on White continue to be an inspiration to me. The Art Institute of Chicago and The Museum of Modern Art are collaborating on a forthcoming White retrospective; my co-curators on that project—Sarah Kelly Oehler, Field-McCormick Chair and Curator of American Art, and Mark Pascale, Janet and Craig Duchossois Curator of Prints and Drawings, both at The Art Institute of Chicago—are the best one could hope to work with. I am tremendously thankful for their thoughts and partnership. Other colleagues who provided important information and assistance toward this publication include Dr. Gwendolyn H. Everett, Associate Dean and Director of the Gallery of Art, Howard University; James Glisson and Ming Aguilar at The Huntington Library, Art Collections, and Botanical Gardens, in San Marino, California; and Emily G. Hanna, Senior Curator, Arts of Africa and the Americas, Birmingham Museum of Art. The Davidsons in Los Angeles, Todd Lewis, and halley k harrisburg and Michael Rosenfeld of Michael Rosenfeld Gallery LLC, New York, kindly allowed me to view and reproduce works by White.

At MoMA, I am most grateful to Christophe Cherix, The Robert Lehman Foundation Chief Curator of Drawings and Prints, who suggested I focus on this work and allowed me to follow the path set by my research; and to Jodi Hauptman, Senior Curator in the same department, whose guidance and mentorship as I developed and polished my text have been essential. Other colleagues and friends in the department who provided essential support in myriad ways include Jacqueline Cruz, Emily Cushman, Alexandra Diczok, Samantha Friedman, David Moreno, John Prochilo, Sarah Suzuki, and Jeff White. Charlotte Barat, Curatorial Assistant, and Darby English, Consulting Curator, both in the Department of Painting and Sculpture, and Thomas Lax, Associate Curator in the Department of Media and Performance Art, reviewed and discussed my text with me at different points in its development, and I'm so appreciative of their willingness to share their expertise. Erika Mosier, Paper Conservator, and Karl Buchberg, former Senior Conservator, were always willing to answer media and conservation questions

and kindly tolerated many unannounced intrusions into their lab. Jennifer Tobias, Librarian, provided constant research and moral support. Sydney Briggs, Associate Registrar, and Lily Goldberg, Collection Specialist in the Department of Painting and Sculpture, assisted with elements of this project—I am grateful to have them as colleagues and friends.

The leadership at The Museum of Modern Art creates an environment that supports and encourages deep and meaningful research. For this I thank Glenn D. Lowry, Director; Ramona Bannayan, Senior Deputy Director, Exhibitions and Collections; Todd Bishop, Senior Deputy Director for External Affairs; Peter Reed, Senior Deputy Director for Curatorial Affairs; Kathy Halbreich, Associate Director; James Gara, Chief Operating Officer; Patty Lipschutz and Nancy Adelson, General Counsel; as well as the museum's Chief Curators, Quentin Bajac, Stuart Comer, Rajendra Roy, Martino Stierli, and Ann Temkin. An unparalleled group of trustees and supporters make all of our work here possible; I especially thank the funders who contributed to the purchase of *Black Pope (Sandwich Board Man)*: Richard S. Zeisler (by bequest, and by exchange), The Friends of Education of The Museum of Modern Art, the Committee on Drawings, Dian Woodner, and Agnes Gund. AC Hudgins provided important insight and guidance throughout this project. The support of the Committee on Drawings and Prints, and especially of Kathy and Richard S. Fuld, Jr., has been particularly meaningful.

In the Museum's Department of Publications, I thank Christopher Hudson, Publisher, and Chul R. Kim, Associate Publisher, for their recognition of the importance of contributing to the growing body of literature on White and his work. David Frankel both edited the book and served as a most trusted reader and advisor—I am so grateful to have had his guidance on this project. Amanda Washburn, who designed the book, and Hannah Kim, who managed production, were unfailingly patient, and managed this project with the skill and grace for which they are known.

Laura Neufeld, Assistant Paper Conservator, has become an invaluable collaborator, both on this project and on our continuing research on White for the forthcoming retrospective. I am lucky for the resources of her sharp eye and good humor. Jared Quinton, former summer intern and now a Curatorial Fellow at the Museum of Contemporary Art, Chicago, provided critical early research support for my essay, while Ashley James, former Museum Research Consortium Fellow at the Museum and now Assistant Curator of Contemporary Art at the Brooklyn Museum, was unfailingly generous in sharing her expertise, research, and thoughts on my text and ideas. I am most grateful to all of them for their support and trust.

Esther Adler
Associate Curator, Department of Drawings and Prints

PHOTOGRAPH CREDITS

Major support for this publication is provided by the Riva Castleman Fund for Publications in the Department of Drawings and Prints, established by The Derald H. Ruttenberg Foundation.

Produced by the Department of Publications, The Museum of Modern Art, New York

Christopher Hudson, Publisher
Chul R. Kim, Associate Publisher
Don McMahon, Editorial Director
Marc Sapir, Production Director

Edited by David Frankel
Designed by Amanda Washburn
Production by Hannah Kim
Color separations by t'ink, Brussels
Printed and bound by Gorenjski Tisk Storitve, Slovenia

This book is typeset in Knockout and Post Grotesque. The paper is 150 gsm Magno Plus Silk.

Library of Congress Control Number: 2017948475
ISBN: 978-1-63345-027-1

Published by The Museum of Modern Art
11 West 53 Street
New York, New York
10019-5497
www.moma.org

Distributed in the United States and Canada by Artbook | D.A.P.
75 Broad Street, Suite 630
New York NY 10004
www.artbook.com

Distributed outside the United States and Canada by Thames & Hudson Ltd
181A High Holborn, London WC1V 7QX
www.thamesandhudson.com

Cover: Charles White (American, 1918–1979). *Black Pope (Sandwich Board Man)* (detail). 1973. Oil wash on board, 60 x 43⅞ in. (152.4 x 111.4 cm). The Museum of Modern Art, New York. Richard S. Zeisler Bequest (by exchange), The Friends of Education of The Museum of Modern Art, Committee on Drawings Fund, Dian Woodner, and Agnes Gund, 2013

Back cover and frontis: Charles White at home in Altadena, California, 1971

Printed and bound in Slovenia